IMAGES
of America

VALPARAISO

LOOKING BACK, MOVING FORWARD

IMAGES
of America

VALPARAISO

LOOKING BACK, MOVING FORWARD

Lanette Mullins

ARCADIA

Published by Arcadia Publishing,
an imprint of Tempus Publishing, Inc.
3047 N. Lincoln Ave., Suite 410
Chicago, IL 60657

Printed in Great Britain.

Library of Congress Catalog Card Number: 2002112090

For all general information contact Arcadia Publishing at:
Telephone 843-853-2070
Fax 843-853-0044
E-Mail sales@arcadiapublishing.com

For customer service and orders:
Toll-Free 1-888-313-2665

Visit us on the internet at http://www.arcadiapublishing.com

CONTENTS

ACKNOWLEDGMENTS

I would like to take this opportunity to thank several people for making this project a success. First and foremost, I would like to thank my family for their unwavering support. Had it not been for your help and guidance, this would never have come to fruition. This book was also created through the support of Dr. Nina Corazzo, Pat Dwyer, and Nancy Young from Valparaiso University. Their assistance, friendship, and humor were invaluable in completing this book.

Melvin Doering, Valparaiso University Archivist, was extremely helpful in providing photographs and information on the history of the university. Katharine Wehling, Vice President for Admissions, Financial Aid, and Marketing, also provided advice and information on the history of the university. I would also like to thank Professor Robert Sirko who provided technical support on this project.

Mayor David A. Butterfield and City Clerk-Treasurer Sharon Emerson Swihart provided information on the city and many of the historical photographs used in this book. Sharon Emerson Swihart was also helpful in showing me specific sites throughout the city that would have otherwise been overlooked.

The Historical Society of Porter County was a great help in providing photographs, information, and permission to photograph the interior of the Old Jail Museum. The Porter County Sheriff's Office provided several archival and current photographs used in this book. Chief Deputy David Lain arranged for the photographing of the Thompson Machine gun, used in 1929 by John Dillinger, and the rifle used by Sheriff Freeman Lane in 1938. Emergency 911 Telecommunicator Christine Sears and Sergeant Timothy Emmons were also very helpful in providing photographs.

Valparaiso Community Festivals and Events, Inc. was responsible for providing photographs and information on Orville Redenbacher and the Valparaiso Popcorn Festival. Kurt Gillins, from the Memorial Opera House, provided information and several current and archival photographs of the Opera House. Kyle Kuebler, Manager of the Porter County Municipal Airport, provided information and archival photographs of the airport. Jim Read was most helpful with information concerning the Indiana Aviation Museum. I would like to extend a special thank you to Tom and Brad Cavanaugh of Air One Inc., who graciously provided all of the current aerial photographs used in the book.

INTRODUCTION

Valparaiso, Indiana, is a city that has met the demands of the 21st century and still maintains a coherent community and small town atmosphere. The city's history dates to 1832 with the city's founding as the county seat of Porter County. Valparaiso University has always been an important part in the history of the city and provides cultural, social, and academic opportunities for the community. The city continues to make history every day as it grows and changes to meet the needs of the new millennium.

The site of the present City of Valparaiso was bought from the Potawatomi Indians in 1832. In 1936, the county was separated from LaPorte County and named Porter County in honor of Commodore David Porter of the United States Navy who, though defeated at the Battle of Valparaiso, Chile, played a significant role in the overall victory of the United States in the War of 1812. In 1936, the county commissioners located a site along the ancient Sauk Indian Trail, which ran from present Rock Island, Illinois, to Detroit, Michigan, for the county seat. They named the county seat "Portersville" in honor of Commodore Porter. The town was platted and quickly grew. Though undocumented, it is generally thought that Valparaiso attained its name after local residents heard stories of Commodore Porter's feats during the Battle of Valparaiso, Chile. Whatever the truth to the story, "Portersville" was renamed "Valparaiso" in 1837. In Spanish, Valparaiso means "vale" or "valley of paradise," which is an unusual name because the city is located on a glacial moraine. Regardless of the origins of its name, the city continued to grow.

Valparaiso University, from its inception, has always been an integral part of the city and its history. Established in 1859, the Valparaiso Male and Female College was founded by the Methodist Episcopal Church, making it one of the country's first coeducational institutions. The college ultimately failed because of the Civil War. In 1873, Henry Baker Brown opened the Indiana Normal School and Business Institute using the site's existing buildings. The school was a success and by 1875, there were over 300 students attending classes. In 1879, Mark DeMotte established the Northern Indiana Law School. By 1880, the college had 1,300 students and 28 faculty members. In 1881, Oliver Perry Kinsey joined Brown in his venture and the college continued to prosper. Kinsey and Brown are also responsible for the university's colors: brown from Brown's last name, and gold from Kinsey's red hair. By 1907, the college was second only to Harvard in student attendance, but by 1919 the effects of WWI and conflict

between Brown's son, Henry Kinsey Brown, who had taken over for his father, and Kinsey, the college's finances collapsed. When the college came up for sale in 1923, the Ku Klux Klan showed interest in purchasing the school but never made any direct action to buy. In 1925, the Lutheran University Association of the Lutheran Church – Missouri Synod bought the college and renamed it Valparaiso University. Since that time, the University has grown to over 310 acres and consistently receives national recognition for the excellence of its academic programs.

Today, with a population of 27, 428, Valparaiso is a busy modern city that continues to grow. While expanding in every direction, the city is unique because it has managed to balance its industrial and commercial growth with residential life. The city's residents have access to 600 acres of recreational facilities; academic opportunities through the University, Ivy Tech State College, and Purdue University North Central—Valparaiso Academic Center; hundreds of professional offices and businesses; several spiritual centers; museums; the Popcorn Festival; athletic and recreational clubs; and large commercial centers to cater to their needs. Yet, even with its impressive size, the city has managed to maintain a small town atmosphere. This atmosphere is generated not only by the community but also by the downtown area. The courthouse, built in 1937, is the center of this area which was listed on the National Register of Historic Places in 1990. Shop-lined streets, quaint cafes, and stylish restaurants have made the downtown a popular destination for residents and visitors. Valparaiso is a large city that has kept its roots firmly planted in its rich history, while at the same time, allowing itself to grow and transform into a prospering city of the 21st century.

One

A GLIMPSE OF THE PAST

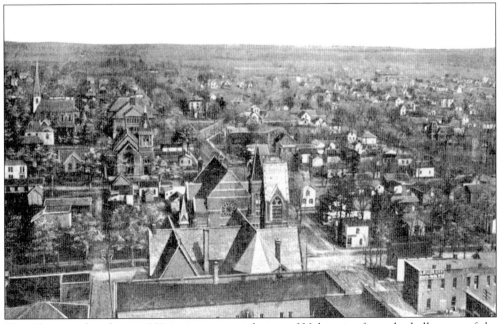

This photograph, taken in 1914, gives an aerial view of Valparaiso from the bell tower of the courthouse. (Photo courtesy of David A. Butterfield.)

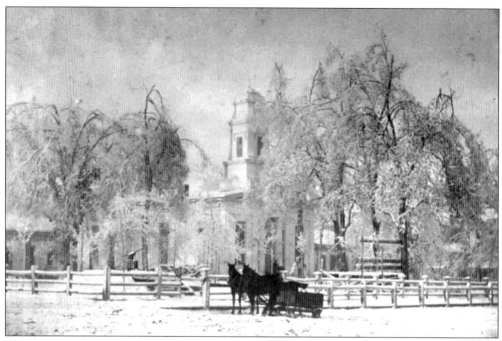

The first courthouse in Valparaiso was built in 1837 and was west of the present courthouse square. The second courthouse, seen in this photograph, was completed in 1853. (Photo courtesy of Historical Society of Porter County.)

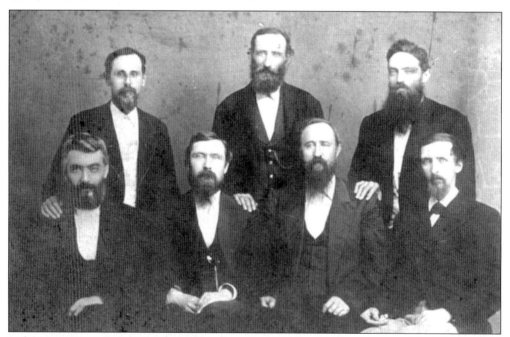

Valparaiso's first band formed in 1858 and consisted of five members. Pictured from left to right are the following: (front row) Newton Arvin, Reason Bell, Mark E. Dolittle, and Octavius M. Benney; (back row) Will Jewell, Aaron Parks, and Lon Salyer. (Photo courtesy of Historical Society of Porter County.)

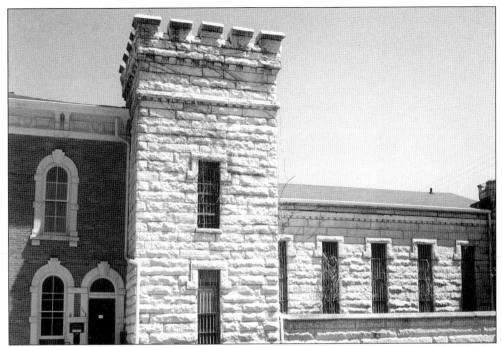

The sheriff's residence that we know today as part of the Old Jail Museum was constructed on Mechanic Street (Indiana Avenue) in 1860. Behind the residence was a log stockade which held the county's prisoners. In 1871, a new county jail was built and served as the sheriff's residence and the county jail until 1974, when the county jail moved to its current location on Franklin Street. (Photo courtesy of Lanette Mullins.)

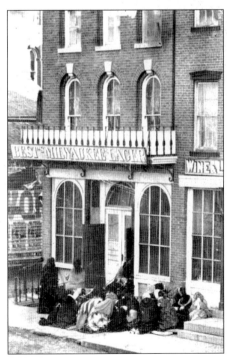

On December 24, 1874, the temperance "Crusaders" of Valparaiso, led by Mrs. Gurney and Mrs. Skinner, sat in prayer in front of Tom Ward's and Conrad Brown's saloons. The women were carrying on the efforts of a temperance movement that began in Ohio in 1873. The women were also reacting to a number of violent fights that had occurred in Valparaiso's saloons. (Photo courtesy of Historical Society of Porter County.)

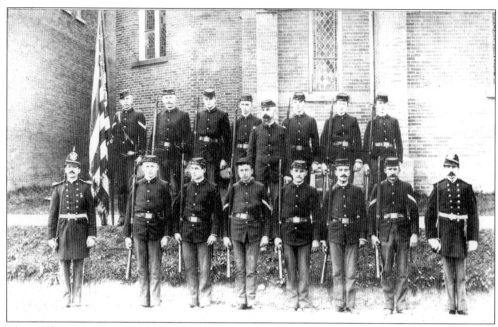

The "Valparaiso Blues" were a local militia unit that was organized in 1889 and was active until 1902. (Photo courtesy of Historical Society of Porter County.)

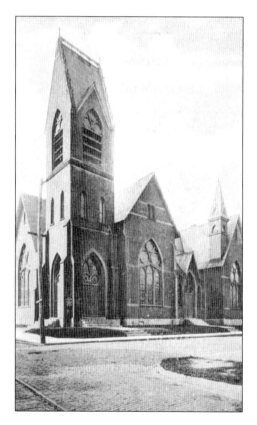

The Presbyterian Church, located on the southwest corner of Jefferson and Franklin, was constructed in 1881. The site is currently a parking lot. (Photo courtesy of Sharon Emerson Swihart.)

The Methodist Church was built in 1886 on the northwest corner of Jefferson and Franklin, where the First United Methodist Church stands today. (Photo courtesy of David A. Butterfield.)

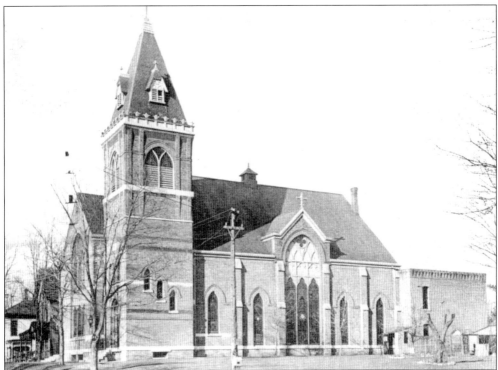

The Christian Church (also know as the First Christian Church Disciples of Christ) was built on the northwest corner of Franklin and Chicago Streets. (Photo courtesy of David A. Butterfield.)

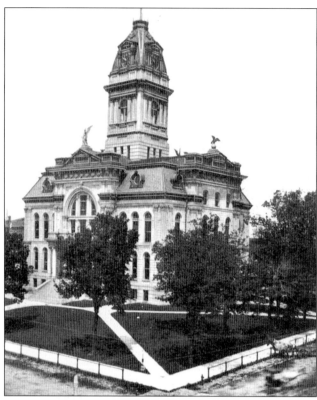

This photograph, taken in 1905, shows Valparaiso's third courthouse. This courthouse, which still stands, in part, was dedicated in 1887 and boasted a bell tower with clocks on all four sides. (Photo courtesy of Sharon Emerson Swihart.)

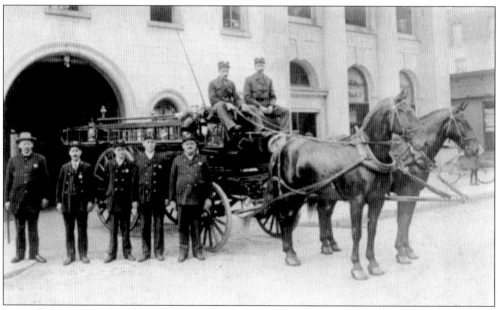

One of Valparaiso's first fire stations was built in 1878 on Mechanic Street (Indiana Avenue). The building also housed the city's government (with the exception of the water department) until 1988, when the city government moved to its current location in the old post office on Lincolnway. The fire department moved to a new station in 1964. Currently, the building houses the Valparaiso City Police. (Photo courtesy of David Lain.)

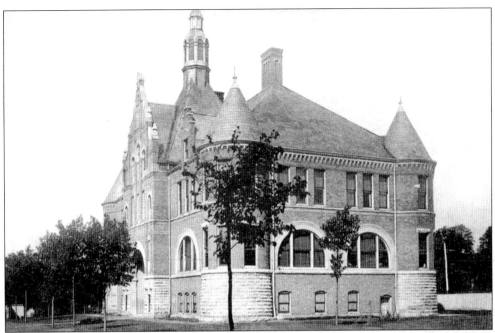

The Gardner School was constructed on Jefferson Street in 1889 and is in use today as the Boys and Girls Club of Porter County. (Photo courtesy of David A. Butterfield.)

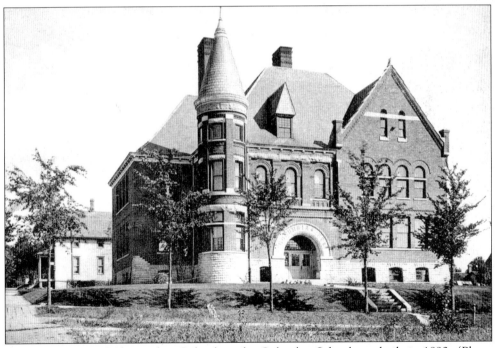

Named in honor of Christopher Columbus, the Columbia School was built in 1892. (Photo courtesy of David A. Butterfield.)

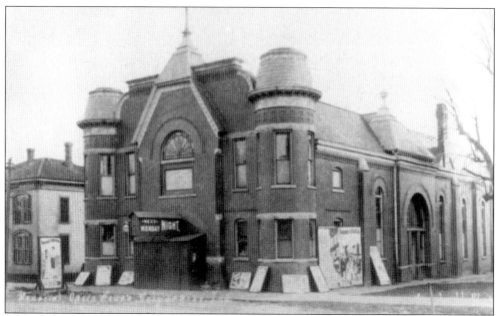

The Grand Army of the Republic built the Memorial Opera House on Mechanic Street (Indiana Avenue) in 1893 to commemorate and honor Civil War Veterans. Local architect Charles Lembke designed the building. Famous actors, like the Marx Brothers and Beulah Bondi, and musicians such as John Philip Sousa, graced the Opera House's stage. (Photo courtesy of Historical Society of Porter County.)

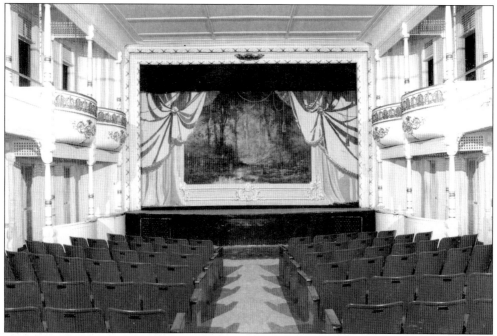

The Opera House experienced a decline in attendance with the advent of the motion picture. Even with a decrease in ticket sales, the Opera House, as seen in this photograph, retained an air of elegance prior to its renovation in 1998. (Photo courtesy of Memorial Opera House.)

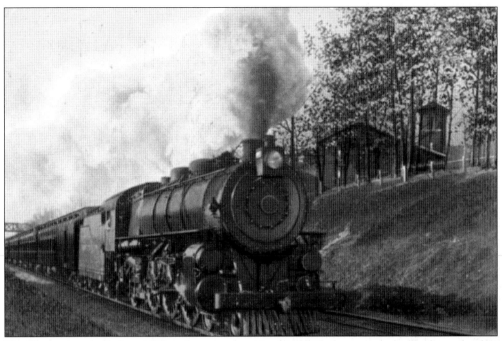

The Pennsylvania Railroad "Flyer," as seen here in this 1917 photograph, boasted speeds of 70 miles per hour. (Photo courtesy of David A. Butterfield.)

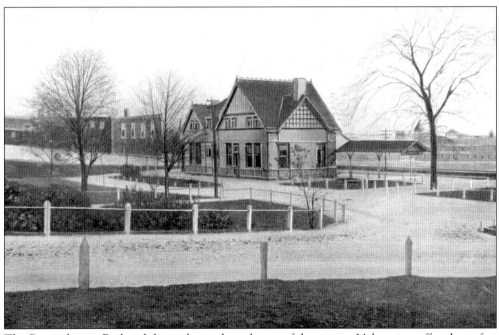

The Pennsylvania Railroad depot, located southwest of downtown Valparaiso, offered comfort and scenic beauty to travelers. (Photo courtesy of David A. Butterfield.)

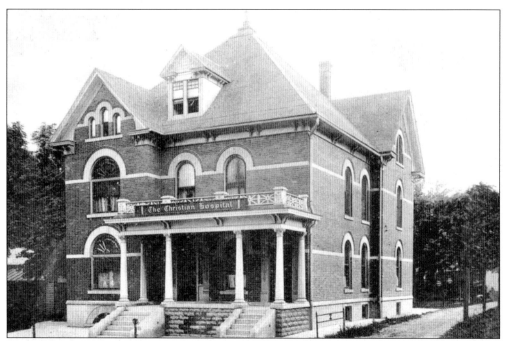

The Christian Hospital (and Training School of Nurses) was built in 1898 by Dr. David Loring and was located on the corner of Michigan Avenue and Jefferson Street. In 1906, the hospital opened under the National Benevolent Association of the Christian Church as the Christian Hospital and maintained seven beds. It closed in 1939, when Porter Memorial Hospital opened. The building was razed in 1978. (Photo courtesy of Sharon Emerson Swihart.)

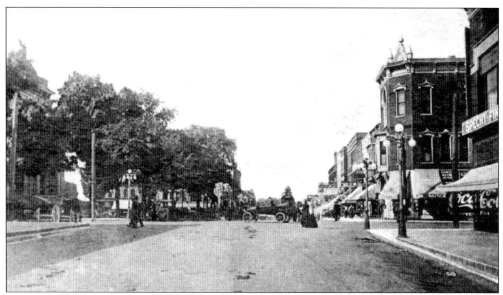

This photograph from the early 1910s shows a bustling downtown. The downtown area, then as today, has always been considered a center for political, social, and economic interaction. (Photo courtesy of Sharon Emerson Swihart.)

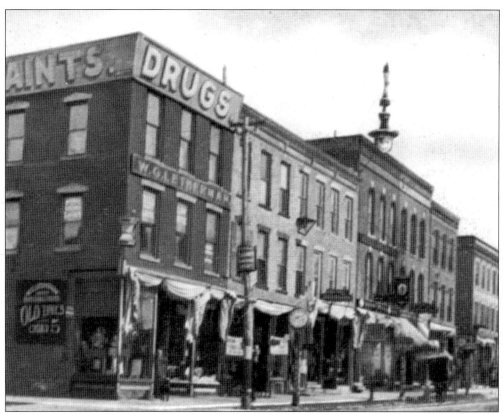

Main Street (Lincolnway) boasted shop-lined streets as seen here in this photograph from 1912. (Photo courtesy of Sharon Emerson Swihart.)

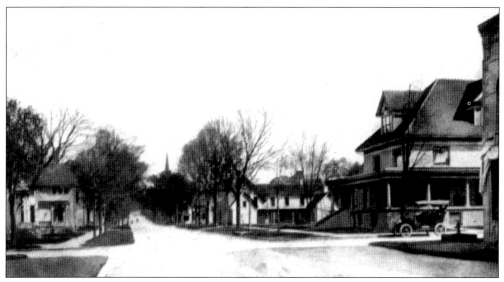

In 1913, Washington Street had already taken on the role of displaying some of Valparaiso's finest houses. (Photo courtesy of David A. Butterfield.)

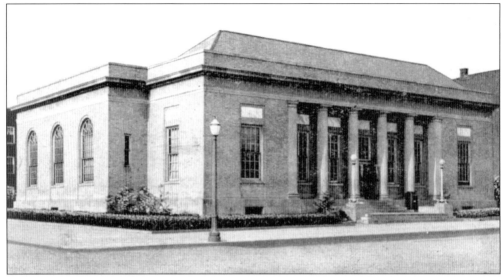

The post office was built in 1918. Today, city hall still houses a branch of the U.S. Post Office. (Photo courtesy of David A. Butterfield.)

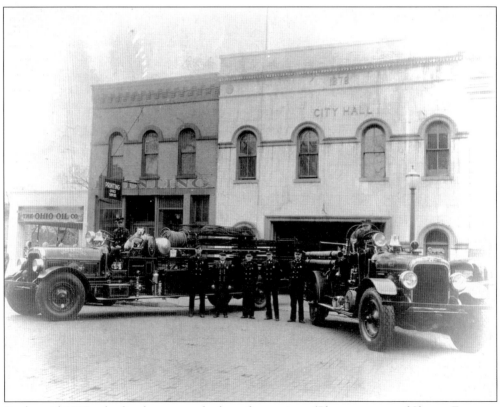

By the mid-1920s, the fire department had two fire engines. (Photo courtesy of Sharon Emerson Swihart.)

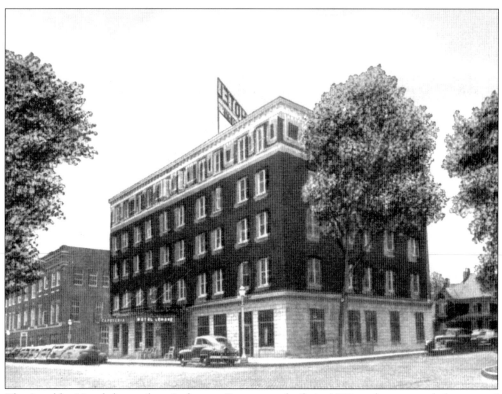

The Lembke Hotel, located on Lafayette Street, was built in 1923 and was regarded as one of the finest in Indiana. The building was razed in 1988. (Photo courtesy of David A. Butterfield.)

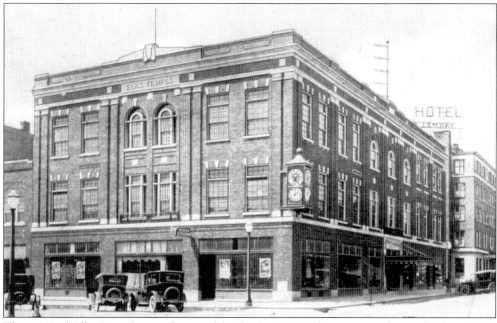

The original Elks Temple was destroyed by fire in 1923. The new temple was built in 1928. (Photo courtesy of David A. Butterfield.)

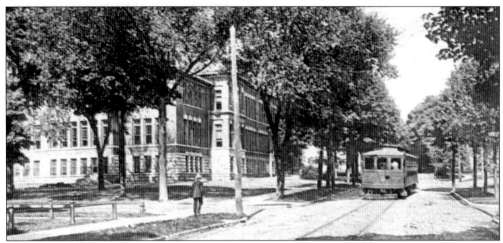

Central Elementary School was originally the site of the Collegiate Institute. The site became the home of Valparaiso High School in 1904. In 1938, the structure was damaged in a fire, leaving the current structure. Running alongside the school, on Franklin Street, is the Interurban, Valparaiso's streetcar system, which began on September 4, 1910, and ended in 1938. (Photo courtesy of Sharon Emerson Swihart.)

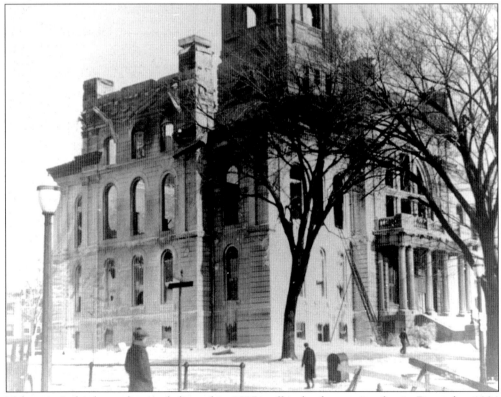

Valparaiso's third courthouse, dedicated in 1887, suffered a devastating fire in December 1934 that completely destroyed the bell tower and much of the interior of the building. In 1937, 100 years after the first courthouse was completed, the present courthouse was rebuilt. (Photo courtesy of Historical Society of Porter County.)

The October 1938 issue of *Official Detective Stories* ran a story by Gorden E. Fewell titled, "The Four-State Pact Gets Its Man." The story was about the courageous efforts and key role of Sheriff Freeman Lane (pictured here), Chief of Police A.C. Witters, and Capt. Charles Gilliland in the apprehension of the Easton Brothers, two hardened criminals. (Photo courtesy of Historical Society of Porter County.)

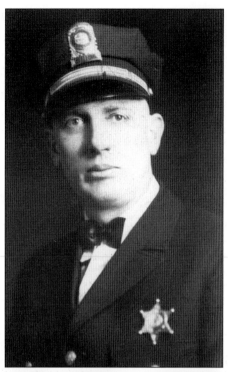

Orelle and Clarence Easton, after killing an Indiana State Trooper and kidnapping a LaPorte Sheriff's Deputy, led law enforcement agents in a multi-state car chase. After eluding capture for a short period of time, the Eastons were found by Lane, Witters, and Gilliland, who were heavily armed and driving this armor-plated city squad car with bullet-proof windows. The lawmen credited the car with saving their lives. (Photo courtesy of David Lain.)

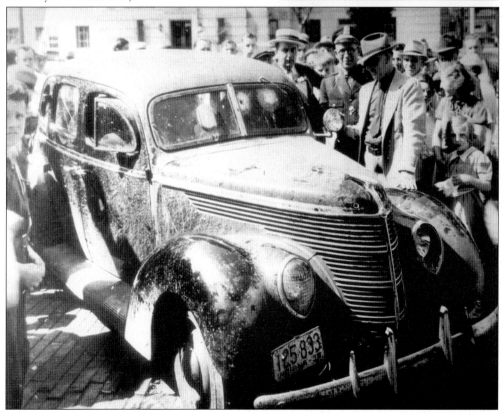

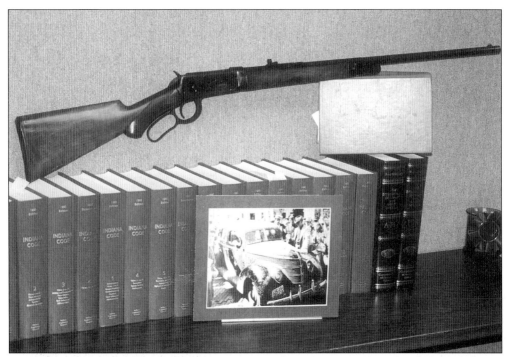

Pictured with the photograph of the armored car, this rifle was used in the capture of Orelle Easton and the death of his brother Clarence Easton. (Photo courtesy of Lanette Mullins.)

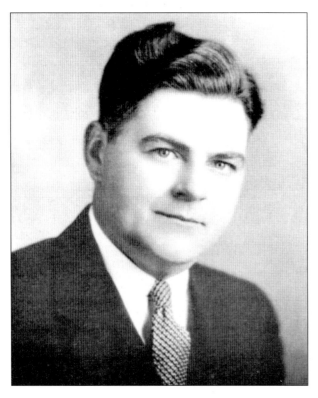

In 1929, Lake County Sheriff, Neil Fry, borrowed the Porter County Sheriff's Thompson Machine gun (Tommy gun) to guard John Dillinger, who was then a prisoner at the Lake County Jail. When Dillinger escaped, he took the Porter County Sheriff's Tommy gun, which later became the last gun Dillinger used for a bank robbery. (Photo courtesy of David Lain.)

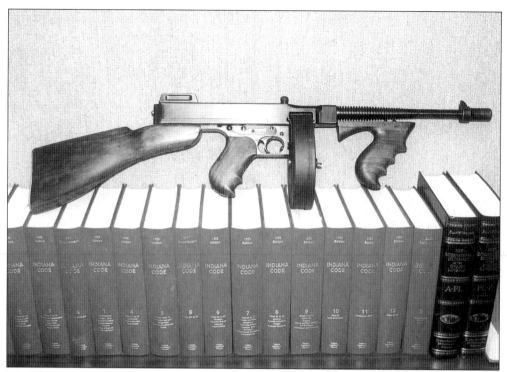

The Tommy gun, pictured here, was found in excellent condition in Lake Michigan off the Chicago shore. The FBI kept the gun until May 2001, when it was returned to the Porter County Sheriff's Office. (Photo courtesy of Lanette Mullins.)

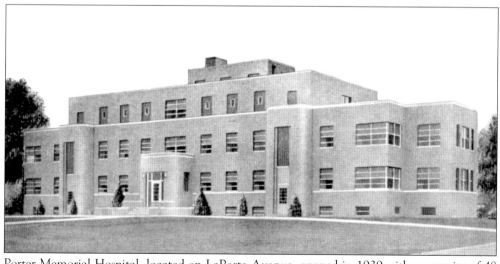

Porter Memorial Hospital, located on LaPorte Avenue, opened in 1939 with a capacity of 48 beds. (Photo courtesy of David A. Butterfield.)

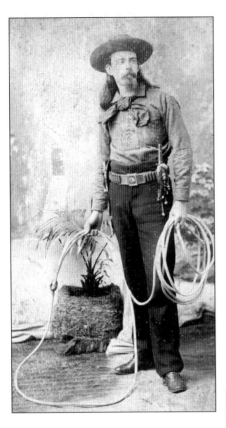

John "Bronco John" Harrington Sullivan traveled from New Jersey to America's West to live and work. There he met some of the West's most famous characters. He traveled with his own Wild West show and developed two famous gun tricks: the "Bronco Reverse," the fastest shot ever accomplished with a weapon, and the "Bronco Belt Draw," the fastest draw from a concealed position with a heavy gun. (Photo courtesy of Historical Society of Porter County.)

"Bronco John" counted many Wild West favorites among his friends. Seen here with William F. "Buffalo Bill" Cody, "Bronco John" was also friends with James Butler "Wild Bill" Hickok, "Bat" Masterson, and "Calamity" Jane. "Bronco John" died September 24, 1851, in Valparaiso, Indiana. (Photo courtesy of Historical Society of Porter County.)

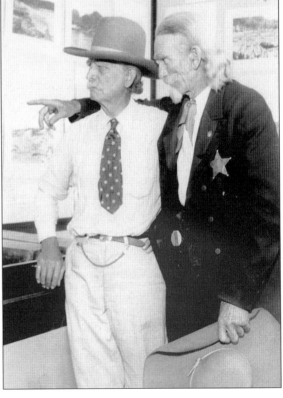

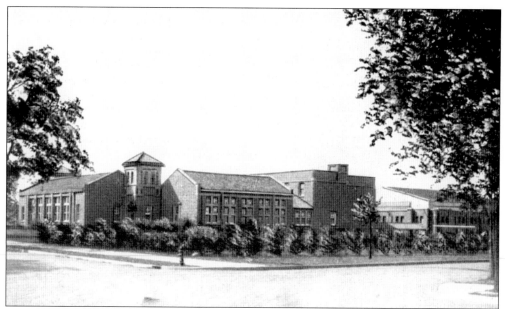

Valparaiso High School was built in 1927. Today the site is home to Benjamin Franklin Middle School. (Photo courtesy of David A. Butterfield.)

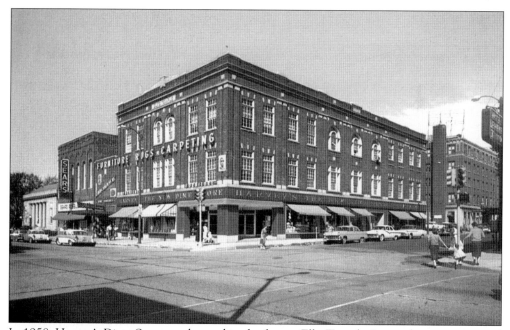

In 1958, Harvey's Dime Store was located in the former Elks Temple. It was the main store and buying center for the northern Indiana regional dime store chain. (Photo courtesy of Sharon Emerson Swihart.)

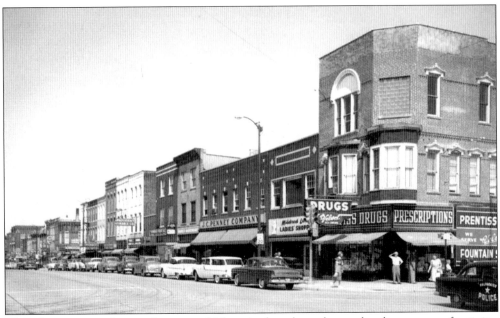

Though times may change, downtown Valparaiso has always been a bustling center of activity. As seen in this 1956 photograph, the streets were lined with quaint shops and department stores. The pharmacy on the corner of Franklin Street and Lincolnway is, today, Binders Jewelry. (Photo courtesy of Sharon Emerson Swihart.)

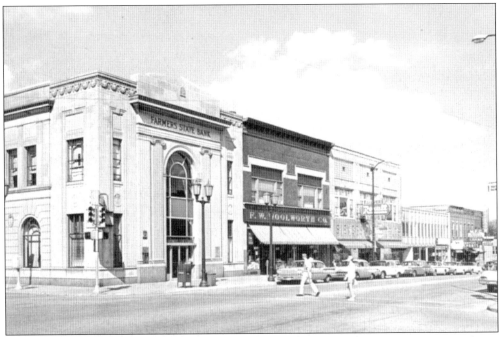

This photograph from the 1960s shows Lincolnway looking east. Located on the northeast corner of Franklin Street and Lincolnway was Farmers State Bank. Today the bottom floor is still a bank and the second floor houses the law firm of Hoepner, Wagner & Evans, LLP., the largest law firm in Porter County. (Photo courtesy of David A. Butterfield.)

The Porter County Municipal Airport, located just outside the Valparaiso's city limits, was constructed in 1949. The original terminal was demolished in the 1980s. (Photo courtesy of Porter County Municipal Airport.)

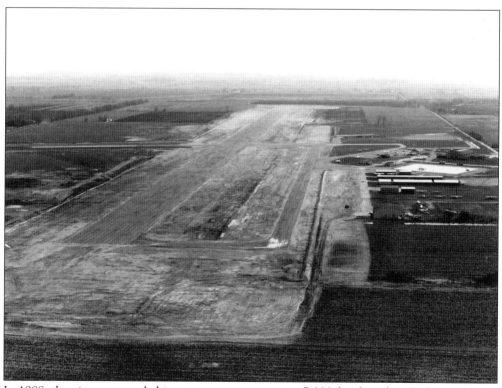

In 1988, the airport extended its runways: east to west—7,000 feet long by 150 feet wide, and north to south—4,000 feet long by 75 feet wide. Today, the airport is able to handle business jets including 737s, 727s, and DC-9s. (Photo courtesy of Porter County Municipal Airport.)

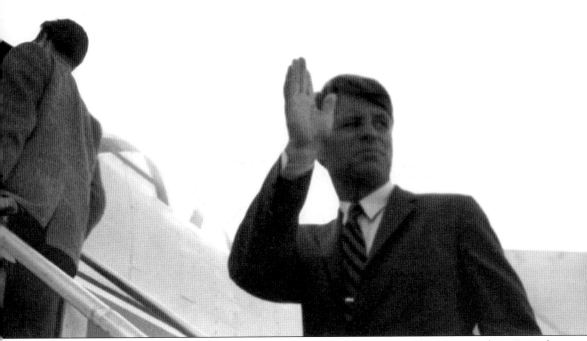

Porter County Municipal Airport serves as a convenient connection for many travelers. One of the most significant visitors to the airport was presidential candidate Senator Robert F. Kennedy, who addressed citizens and Valparaiso University students in May 1968. Kennedy, who joyfully waved to the photographer, was assassinated one month later. (Photo courtesy of Porter County Municipal Airport.)

Two

VALPARAISO UNIVERSITY
THEN AND NOW

By 1913, Valparaiso University's campus was well developed. The student body exceeded 5,000 students with a faculty of 166. Tuition was $18 per 12 weeks and books, room, and board ranged from $1.70–$2.75 a week. Subjects such as teacher preparation and education, elocution and oratory, medicine, law, scientific courses, psychology, pedagogy, phonography, and typewriting were taught. (Photo courtesy of David A. Butterfield.)

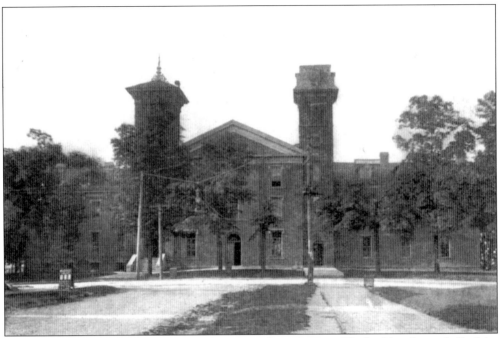

The Old College Building was built in 1860 on College Avenue. The building housed all of the administration offices, the music department, and the auditorium until 1923, when the building was destroyed by fire. (Photo courtesy of Sharon Emerson Swihart.)

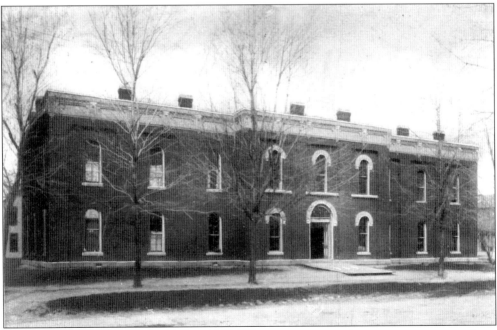

The Flint family built Heritage Hall in 1875. When new, it was a three-story structure and was used as a boarding hall. In 1879, the third story was destroyed by fire and the building was sold to Richard Heritage, a music teacher, that same year. For a short time Heritage Hall served as the university's library. (Photo courtesy of Sharon Emerson Swihart.)

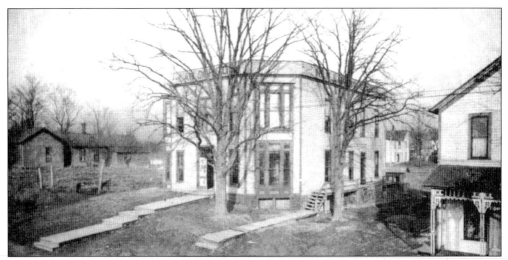

Valparaiso University's law school started out as the private residence of one of the university's art professors. In 1879, the house was bought by Mark DeMotte and given the name Northern Indiana Law School. The building was demolished c. 1940. (Photo courtesy of David A. Butterfield.)

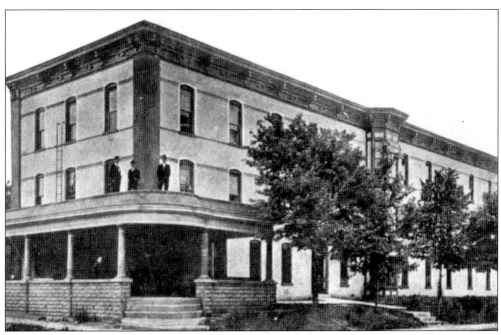

Stiles Hall was built in 1880 and was located on the northwest corner of Union and Greenwich Streets. The Stiles family rented rooms to university students but with strict regulations on behavior. The hall became known as "Libby's Prison" because of Mrs. Stiles' rules and the dismal living conditions. The university bought the building in 1945 and it was demolished in 1973. (Photo courtesy of David A. Butterfield.)

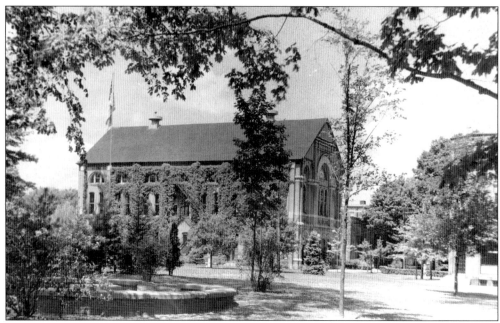

The university's first auditorium was built in 1892. It was later converted to a chapel that contained an organ and seating for 2,000. The building burned down in 1956. (Photo courtesy of Valparaiso University Archives.)

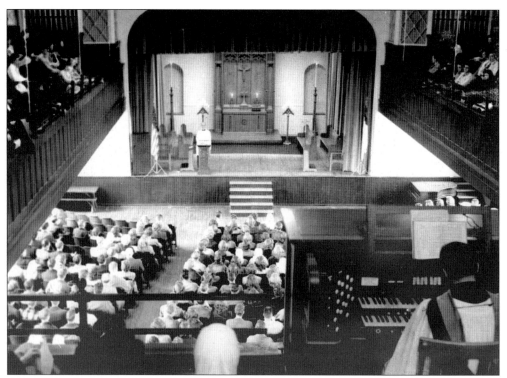

This photograph from the 1950s shows the interior of the chapel/auditorium during a church service. (Photo courtesy of Valparaiso University Archives.)

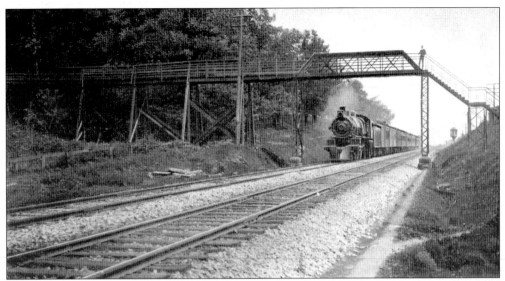

An important feature of the university was Lover's Repose Bridge, located behind the old Science Hall. The footbridge crossed the Pennsylvania Railroad tracks. The tradition was that if, during a crossing with one's significant other, a train came along, the couple had to kiss and remain kissing until the train passed. The bridge was torn down in the 1960s. (Photo courtesy of Sharon Emerson Swihart.)

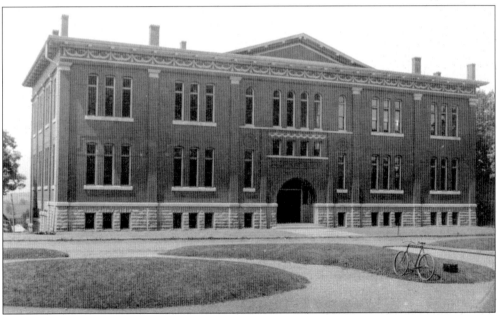

The Science Hall was built in 1900 and housed the Science Department until Neils Science Center was built in 1967 on the West Campus. The hall was renamed Baldwin Hall in 1959 for Samantha "Mantie" Baldwin, a major figure of the university in its pre-Lutheran era. Baldwin Hall housed the Art Department until it moved to the University Center for the Arts in 1996. Baldwin was razed later that same year. (Photo courtesy of Valparaiso University Archives.)

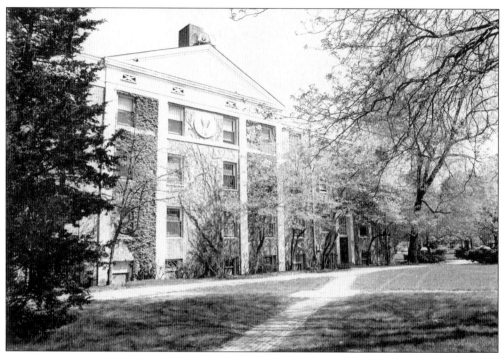

Lembke Hall, named for local architect Charles Lembke, was built in 1902, and housed male students and fraternities. It was demolished in 1996. (Photo courtesy of Valparaiso University Archives.)

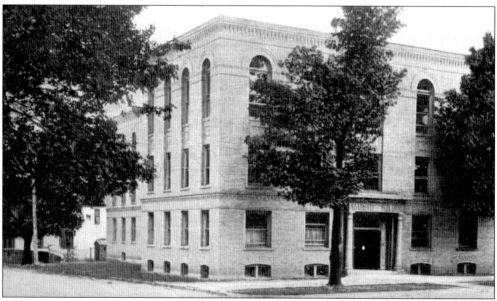

The Music Building, later renamed Kinsey Hall in honor of former faculty member and founder Oliver Perry Kinsey, shared its first floor with some of the university's administration offices. In 1970, the building burned down. Three students were found guilty of arson and expelled. (Photo courtesy of Valparaiso University Archives.)

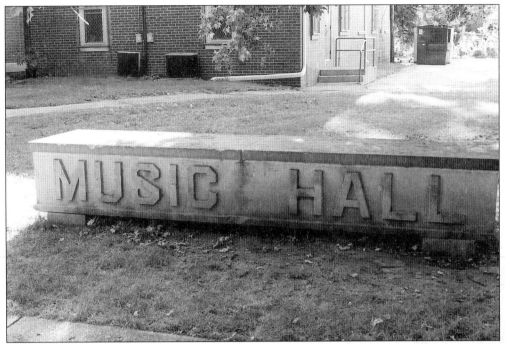

Today, all that remains of Kinsey Hall is a stone that reads, "Music Hall." The stone is used as a bench and is located outside of Heritage Hall. (Photo courtesy of Lanette Mullins.)

The Alturia, built in 1909 and located at the corner of College and Brown Street, was home to the women's dorm and sororities. The building was sold and eventually razed in 1985. (Photo courtesy of Valparaiso University Archives.)

DeMotte Hall, named for Mark DeMotte who founded the university's law school, was built in 1914 and officially named DeMotte Hall in 1959. The building was demolished in 1996. (Photo courtesy of Valparaiso University Archives.)

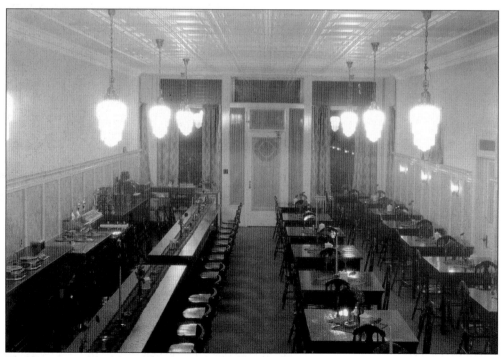

The Brown and Gold Coffee Shop was built c. 1900 and named for the university's colors. Located across from the old chapel/auditorium, the coffee shop was frequently visited by students and faculty. (Photo courtesy of Valparaiso University Archives.)

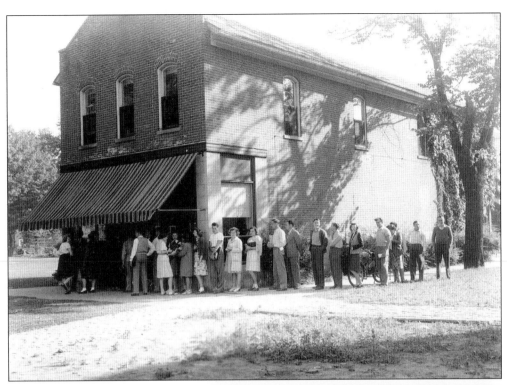

The Brown and Gold Coffee Shop later became the university's book store, and in 1960, the faculty club. In this photograph from the late 1940s, students line up outside the store to buy their books. (Photo courtesy of Valparaiso University Archives.)

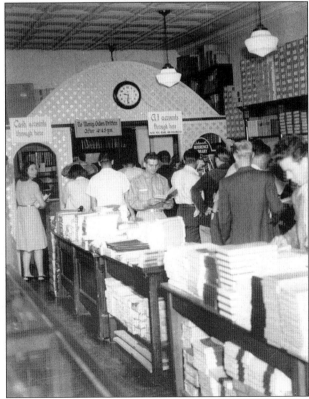

The interior of the book store was very crowded. When this photo was taken in 1948, GIs, like the one in the center of the photograph, paid for their books at a special teller window, as indicated by the sign on the back wall. The post-war increase in students attending the university stimulated the university's economy. The building was demolished in 1986. (Photo courtesy of Valparaiso University Archives.)

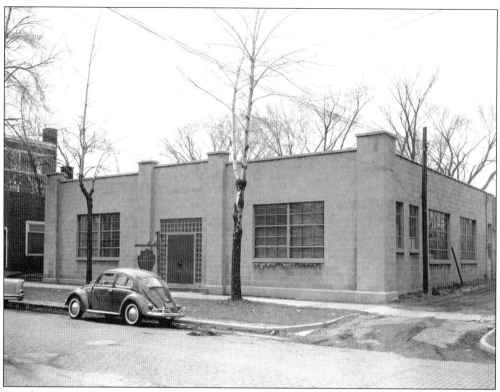

Moody Lab was originally a machine shop. The building served as an annex for the Engineering Department. It was named for former Dean Howard Moody and housed the Psychology Department until 1995. In 1996, the building was sold and became Hilltop Neighborhood House. (Photo courtesy of Valparaiso University Archives.)

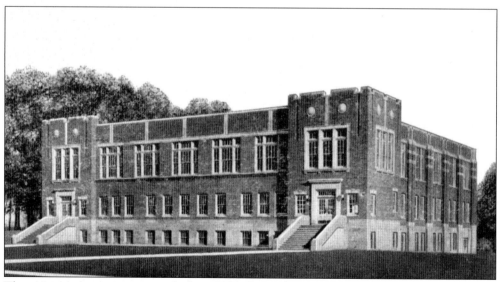

The university's gymnasium was built in 1939. Since that time, two additions have been made: in 1963, a swimming pool was added, and in 1984, a 6,000 seat arena was built on to the west and north sides of the building. (Photo courtesy of David A. Butterfield.)

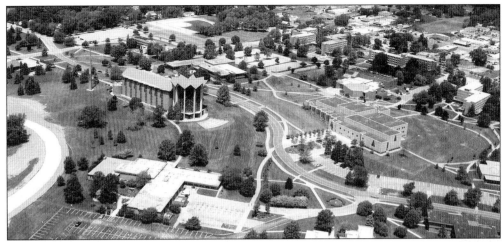

This aerial photograph shows Valparaiso University as we see it today. The university campus stretches for 310 acres and has six colleges. (Photo courtesy of Brad Cavanaugh, Air One Inc.)

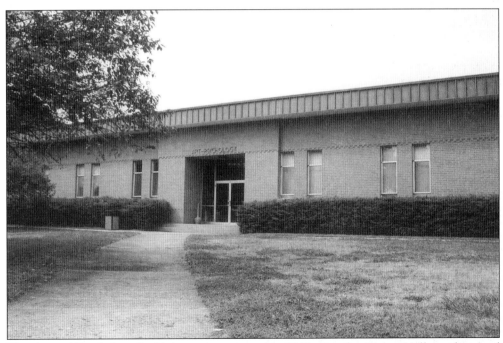

The Art and Psychology Building was constructed in 1947, just after Kinsey Hall was destroyed by arson. The construction of the new music building by the students was such an amazing feat that Hollywood immortalized the event in the 1952 movie, *Venture of Faith*. Today the building houses the Psychology Department's labs, faculty offices, and classrooms and the Art Department's studio arts, such as sculpting and painting. (Photo courtesy of Lanette Mullins.)

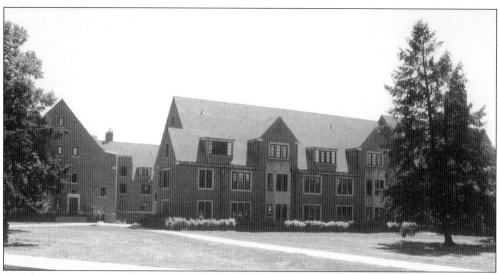

Guild and Memorial Halls were built in 1947. Guild Hall was named in honor of the University Guild. Both halls have recently undergone renovation, which included the addition of air conditioning in all of the rooms. (Photo courtesy of Lanette Mullins.)

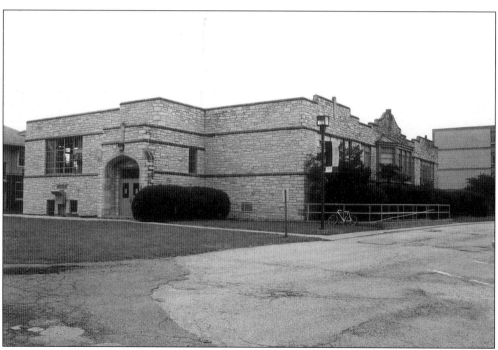

When built in 1950 on LaPorte Avenue, Miller Hall was the Immanuel Lutheran Church. The university bought the building and named it Miller Hall after Rev. Jacob Miller who was a supporter of the Lutheran University Association. The hall has housed the Education Department and classes since 1966. (Photo courtesy of Lanette Mullins.)

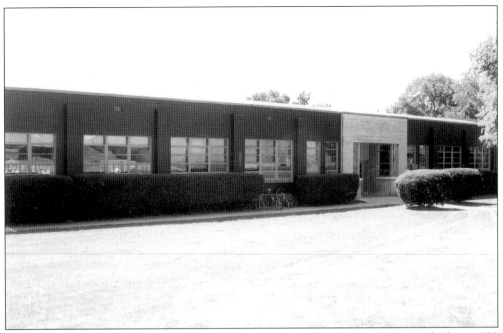

Kroencke Hall was named for Frederick Kroencke, former dean of faculty. It was built in 1952 and today houses a weight training facility and small performing arts theatre. (Photo courtesy of Lanette Mullins.)

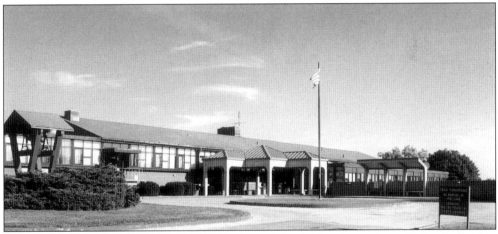

The Student Union was built c. 1955–56 and was financed by the students. Today the Union is an important center for student life. It houses many organizations such as the Student Senate and Union Board. The headquarters for the university's yearbook, the *Beacon*, and the university's literary magazine, the *Lighter*, also calls the Union home. Also in the Union is a 24-hour computer lab, information desk, and Jester's and the Round Table, two of the university's dining areas. (Photo courtesy of Lanette Mullins.)

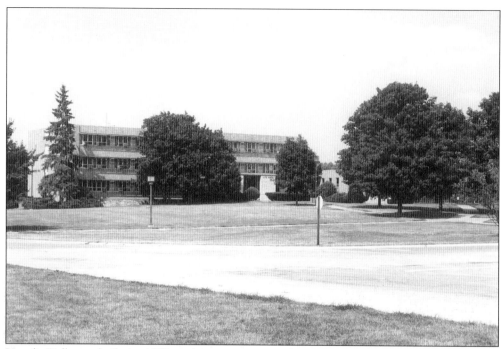

Huegli Hall was built in 1957 to house women studying to enter the Lutheran Deaconess Association. It was lovingly nicknamed "Deaconess Hall." The building was later named for Dr. Albert Huegli who was the former vice president of student affairs. Today, Huegli Hall houses dean and faculty offices for the College of Art and Sciences. (Photo courtesy of Lanette Mullins.)

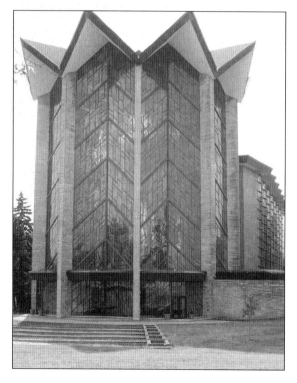

The Chapel of the Resurrection was built in 1959. The chapel is one of the largest collegiate chapels in the United States with enough seating for 3,000 guests. The chapel has a world-renowned organ, but the most striking feature of the chapel is the 94-foot high Mundeloh stained glass windows. The Brandt Campanile is 140 feet tall and sounds out every quarter of the hour. (Photo courtesy of Lanette Mullins.)

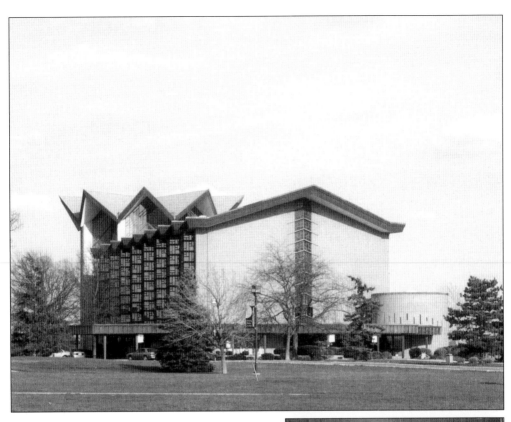

Looking east, the sheer size of the chapel is remarkable. It can be seen from just about any part of the east campus. (Photo courtesy of Lanette Mullins.)

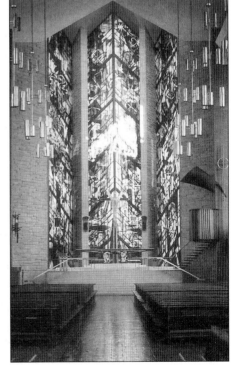

The real glory of the chapel is its Mundeloh stained-glass windows. Seen from the interior, the windows are illuminated by sunlight and the magnificent colors come to life. (Photo courtesy of Lanette Mullins.)

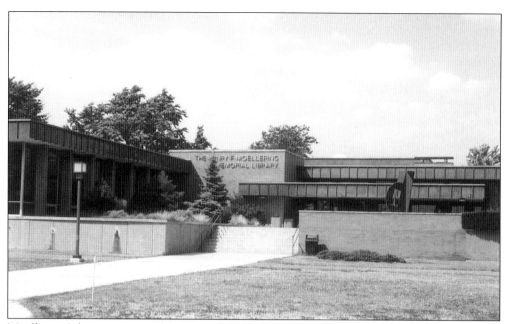

Moellering Library was named for Henry Moellering and was built in 1959. It is the university's main library. Soon, the library will move to its new location, across the street and directly west of the chapel. (Photo courtesy of Lanette Mullins.)

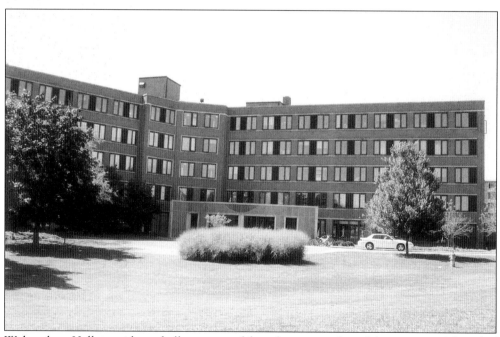

Wehrenberg Hall, a residence hall, was named for a former member of the university's board of directors, Henry C. Wehrenberg, and his wife. The building was renovated in the early 1990s. (Photo courtesy of Lanette Mullins.)

Scheele Hall was built in 1961 and was named for Minna Scheele. The residence hall houses the university's seven sororities: Alpha Delta Pi, Chi Omega, Delta Delta Delta, Gamma Phi Beta, Kappa Delta, Kappa Kappa Gamma, and Pi Beta Phi. (Photo courtesy of Lanette Mullins.)

The university's fraternities are housed in individual houses off campus. The nine fraternities are Phi Delta Theta, Phi Kappa Psi, Phi Mu Alpha Sinfonia, Phi Sigma Kappa, Sigma Chi, Sigma Phi Epsilon, Sigma Pi, Sigma Tau Gamma, and Theta Chi. (Photo courtesy of Lanette Mullins.)

47

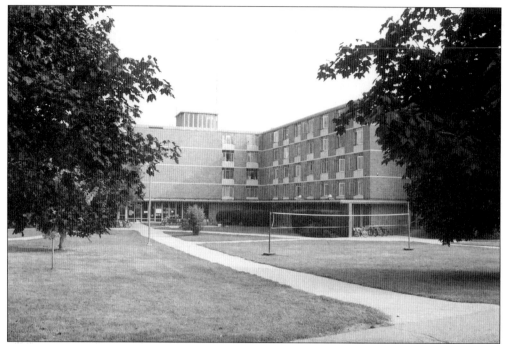

Brandt Hall was built in 1962. A residence hall, it is named for Paul Brandt, a former member of the university's board of directors. (Photo courtesy of Lanette Mullins.)

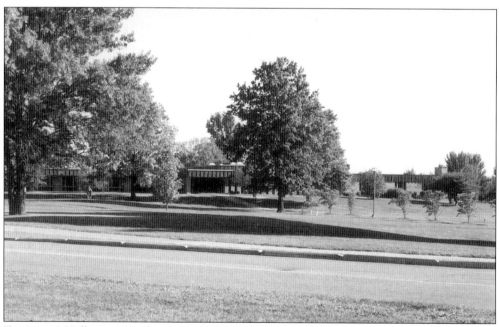

Kretzmann Hall was named in honor of Rev. Otto Paul Kretzmann, former president of the university. The building was constructed in 1963 and was originally named Wesemann Hall. It was renamed Kretzmann Hall after the current Wesemann Hall was built in 1986. Today it houses the university's administration offices, including Admissions, Financial Aid, Student Affairs, the University Guild, and Graduate Division. (Photo courtesy of Lanette Mullins.)

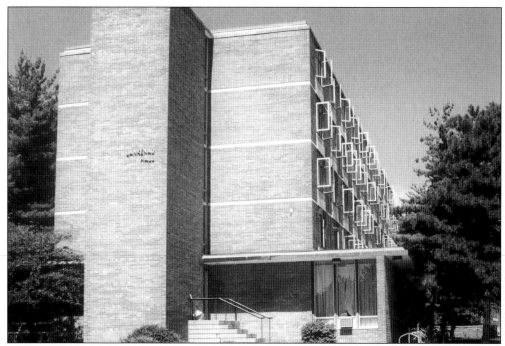

Lankenau Hall was built in 1964 and was named for Rev. Francis Lankenau who was vice president of the Central District of the Lutheran Church–Missouri Synod. The residence hall houses mostly first year students. (Photo courtesy of Lanette Mullins.)

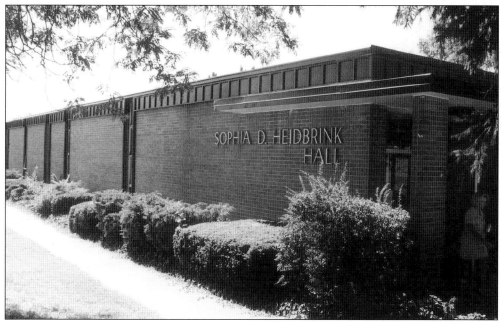

Built in 1965, Heidbrink Hall was named for Sophia Heidbrink, former secretary to the president and University Guild. The hall houses the Social Work and Sociology Departments and classrooms, as well as the INTERLINK program, which provides training and orientation to international students who plan to work in the United States. (Photo courtesy of Lanette Mullins.)

The Smoke Entrance Tower, also know as the east gate, is presently the main entrance to campus. It was built in 1965 in memorial of Fred Smoke, a local philanthropist. (Photo courtesy of Lanette Mullins.)

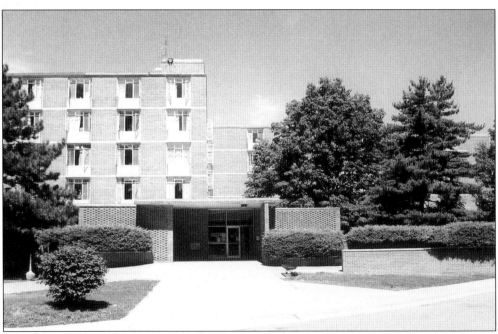

Another of the university's residence halls, Alumni Hall, was built in 1966 and was named to honor the support of Valparaiso University's alumni. (Photo courtesy of Lanette Mullins.)

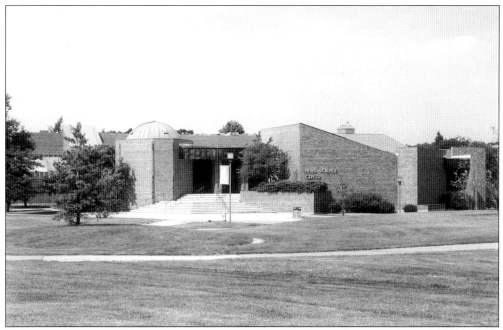

Neils Science Center was built in 1967 and named for Julius and Mary Neils. The Science Center contains classrooms and labs, a planetarium, a particle accelerator, and a sub-critical nuclear reactor. (Photo courtesy of Lanette Mullins.)

Meier Hall was built in 1968, but was not known by that name until 1974, when it was named in honor of Dr. Richard Meier, former treasurer for the university's board of directors. The hall houses inter-disciplinary classrooms, the International Studies Office, and Foreign Language Department. (Photo courtesy of Lanette Mullins.)

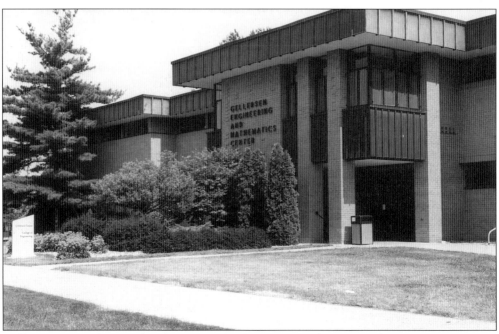

Gellerson Center houses the classrooms, faculty offices, and computer labs for the College of Engineering and the Math and Computer Science Department. The building is named for university supporter William Gellerson and was built in 1968. The College of Engineering's programs are ABET accredited. (Photo courtesy of Lanette Mullins.)

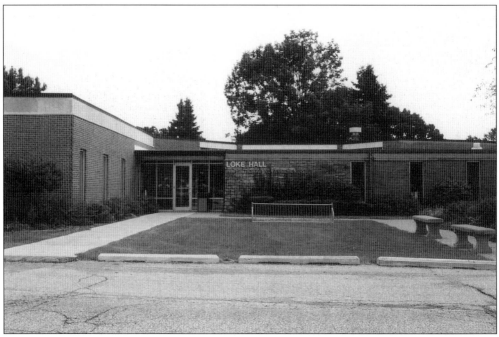

Loke Hall, built in 1968, was named for Mr. and Mrs. Edgar Loke and was the home of the Economics Department. Today, the building houses the offices of Institutional Advancement and Alumni Relations. (Photo courtesy of Lanette Mullins.)

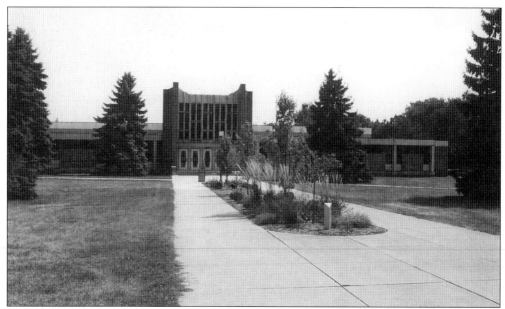

Mueller Hall is the home of Christ College, Valparaiso University's Honors College. The hall was built in 1969 and was named for Ewald and Joan Mueller. Besides inter-disciplinary classrooms and faculty offices, it also houses the Geography and Meteorology Departments. The student-run weather center has continuous access to data from the National Weather Service satellites. Mueller Hall is home to one of the university's art galleries. (Photo courtesy of Lanette Mullins.)

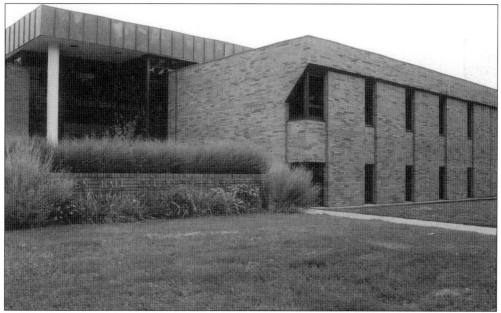

Valparaiso University's College of Nursing is located in LeBien Hall on LaPorte Avenue. The Hall was built in 1971 and named for Alfred J.W. and Elfrieda LeBien. The nursing students provide over 20,000 voluntary hours to hospitals annually. The hall also has faculty offices, labs, and classrooms. (Photo courtesy of Lanette Mullins.)

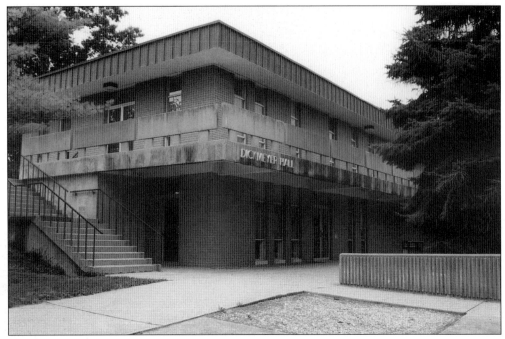

Dickmeyer Hall was built in 1972 and named for W. Charles Dickmeyer, former chairman of the university's board of directors. The building housed the Music Department until the University's Center for the Arts was completed in 1996. Today it is the site of the Psychology Department offices and classrooms. (Photo courtesy of Lanette Mullins.)

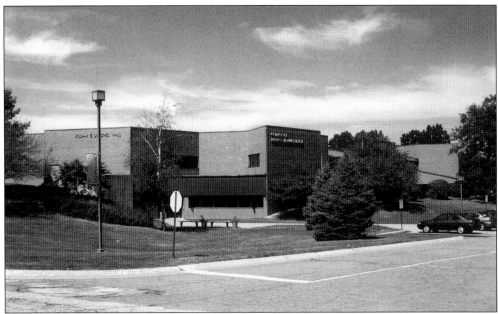

The College of Business Administration, its classrooms, and labs are housed in Urschel Hall, which was built in 1979 and named for William E. Urschel, founder of Urschel Laboratories. The College has the distinction of having its undergraduate-only programs accredited by the American Assembly of Collegiate Schools of Business. (Photo courtesy of Lanette Mullins.)

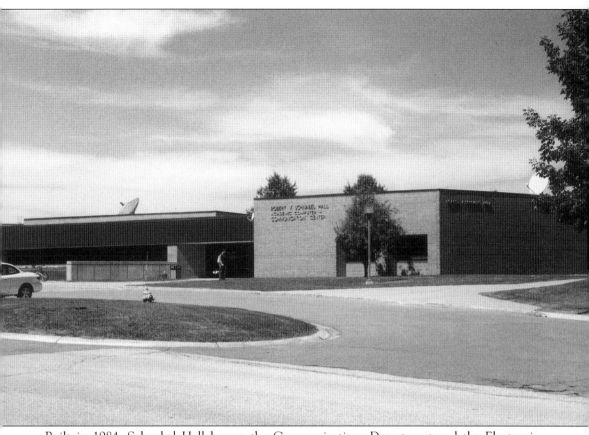

Built in 1984, Schnabel Hall houses the Communications Department and the Electronic Information Service's Help Desk, the Writing Center, and computer labs. The building was named for President Emeritus Robert Schnabel. (Photo courtesy of Lanette Mullins.)

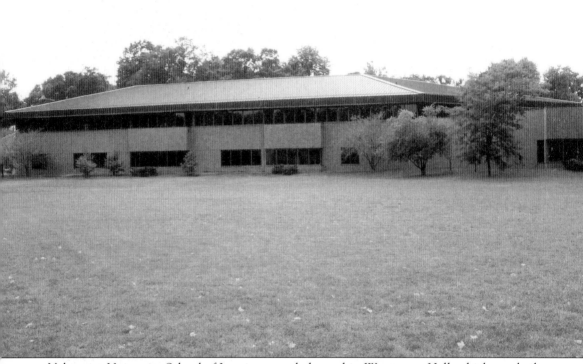

Valparaiso University School of Law is presently housed in Wesemann Hall, which was built in 1986–87 and named for Judge Adolph Wesemann. The School of Law offers several degrees: JD (Juris Doctorate), LLM (a masters in law designed for students wishing to practice international law), JD/MBA (JD with a Masters in Business Administration.), and JD/MA (students choose to receive a masters degree in Psychology or Clinical Mental Health Counseling). Currently, there are 31 full-time teaching faculty and 39 adjunct faculty. The building also houses the Law Library which is a United States Government Depository. Further, the library has full access to a variety of electronic resources for research. The Law School's Legal Clinic offers students the opportunity to learn the law while practicing with a special license from the Indiana Supreme Court. The clinic provides free legal advice and representation to individuals in the community who can not afford to hire an attorney. (Photo courtesy of Lanette Mullins.)

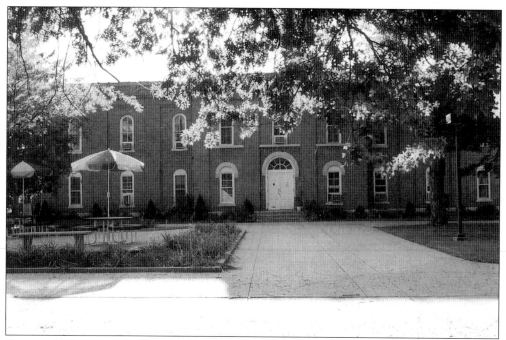

Heritage Hall is not only the oldest building on the university's campus; it also houses the Legal Clinic. There are six practicing area clinics: tax, mediation, civil, criminal, domestic violence, and juvenile. (Photo courtesy of Lanette Mullins.)

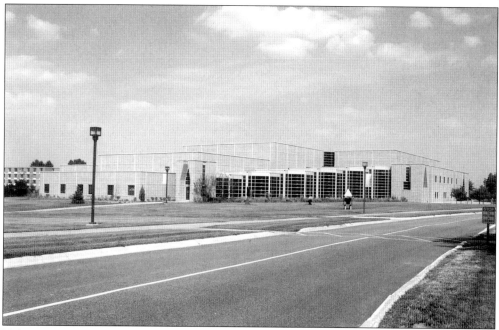

Valparaiso University's Center for the Arts (VUCA) was completed in 1996. This award winning building houses the Art, Music, Theatre, and Television Arts Departments, their faculty offices, and classrooms. (Photo courtesy of Lanette Mullins.)

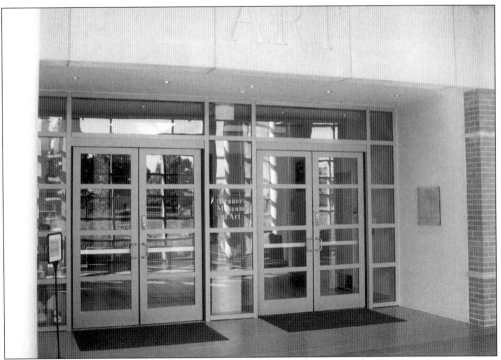

The Brauer Museum of Art, located inside the VUCA, was named after Professor and former Director Richard Brauer. The museum has an impressive permanent collection, as well several loaned exhibits each year. (Photo courtesy of Lanette Mullins.)

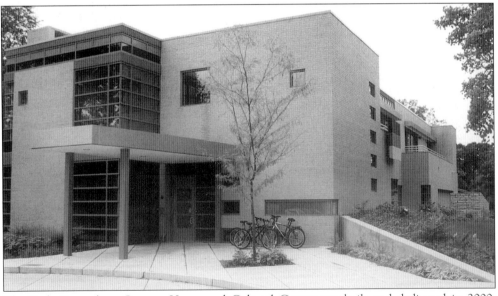

The Kade-Duesenberg German House and Cultural Center was built and dedicated in 2000. Named for the Max Kade Foundation, Richard and Phyllis Duesenberg, and Robert and Lori Duesenberg, the building provides a residence and the opportunity for students to use the German language and be immersed in German culture. The building has been honored with Northwest Indiana's 2001 "Commercial Project of the Year" award. (Photo courtesy of Lanette Mullins.)

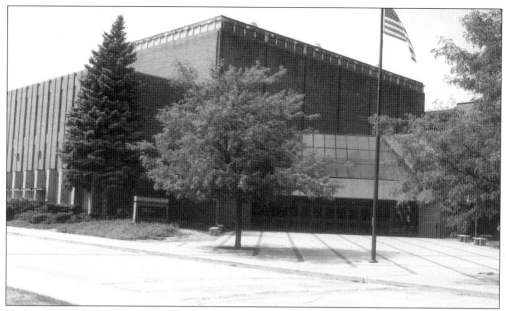

Today the Athletics Recreation Center (ARC) has 7 basketball playing floors, 6 handball/racket ball courts, indoor track, weight room, athletic training rooms, and classrooms. It is estimated that about 75 percent of students participate in sports and other activities. All intercollegiate teams at the university compete at the NCAA Division I Level. (Photo courtesy of Lanette Mullins.)

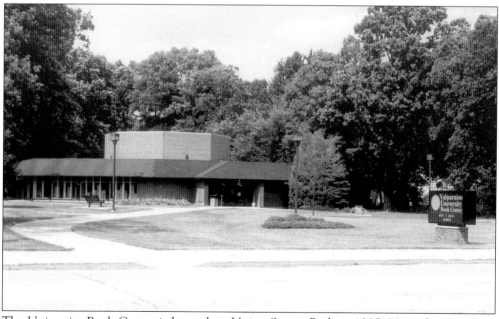

The University Book Center is located on Union Street. Built in 1995–96 on the site of the former Dau-Kreinheder residence halls, the book center provides textbooks, gifts, university apparel, and houses a branch of the university's mail office. (Photo courtesy of Lanette Mullins.)

The Caritas Garden was a gift of the Alpha Xi Epsilon Sorority Alumnae to the university in 1994. In the center of the garden is a sculpture entitled *Caritas* by Valparaiso University Professor Fred Frey. (Photo courtesy of Lanette Mullins.)

Three
VALPARAISO TODAY

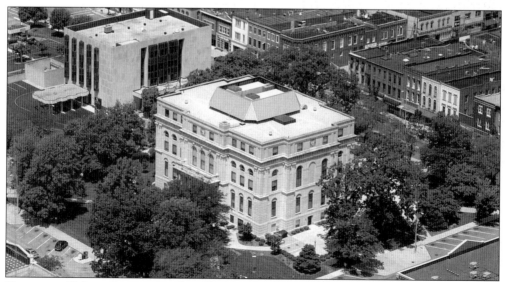

Downtown Valparaiso is centered on the courthouse square, which is created by Washington, Franklin, and Lincolnway Streets and Indiana Avenue. (Photo courtesy of Brad Cavanaugh, Air One Inc.)

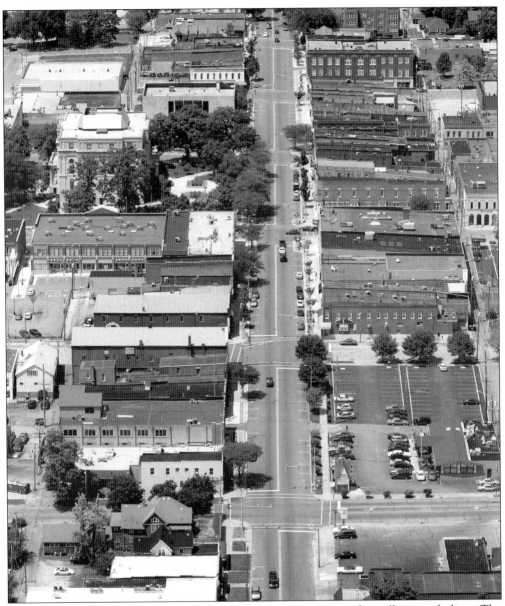

Valparaiso's downtown commercial district retains quintessential small town feeling. The downtown serves multiple roles for the city as well as the county. As the county seat of Porter County, it is the center for city and county government. The Porter County Courthouse and Administration Center, located on Indiana Avenue, as well as the Porter County Sheriff's Department on Franklin Street, connect the downtown to the greater county. City hall and the city police headquarters are also located in the downtown area. The downtown serves as a liaison between Valparaiso's history and its present. Listed in 1990, the entire downtown commercial district—bounded by Jefferson Street, Morgan Boulevard, Indiana Avenue, and Napoleon Street—is among several Valparaiso sites listed on the National Register of Historical Places. The downtown is more than just the governmental center of the city; it is also a social center. Lincolnway is lined with quaint cafes and elegant restaurants, as well as trendy shops. (Photo courtesy of Brad Cavanaugh, Air One Inc.)

The courthouse is a very impressive structure. The 1937 structure that we see here may be missing its bell tower, but it still has clocks on all four sides of the building. (Photo courtesy of Lanette Mullins.)

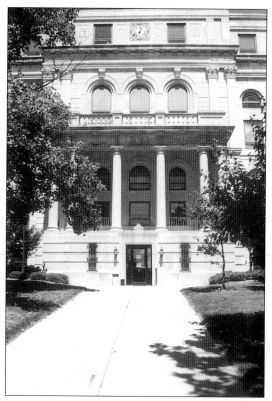

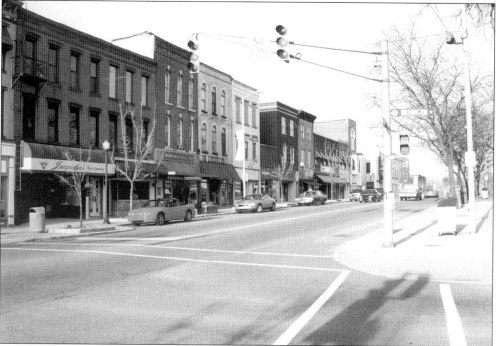

Lincolnway, looking west, is lined with quaint boutiques and fine eating establishments. (Photo courtesy of Lanette Mullins.)

57 Franklin Street was constructed in the early 1990s after a devastating fire destroyed the Lowenstein Building, which was constructed in 1885. The current building was designed to blend in with the existing architecture. (Photo courtesy of Lanette Mullins.)

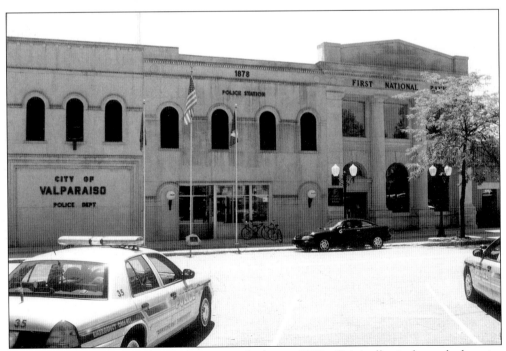

Valparaiso's City Police Department was built in 1878. Originally it housed the city government, a fire station, and the city police. The building has undergone several renovations, but the exterior has maintained its classic look. (Photo courtesy of Lanette Mullins.)

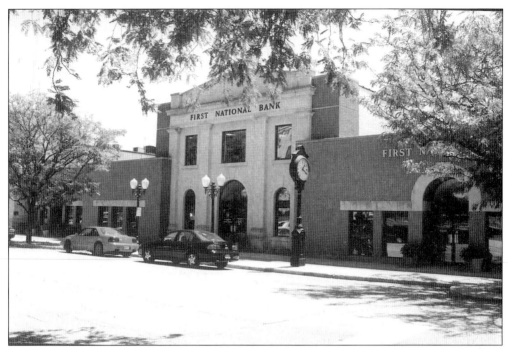

The First National Bank building, located next to the city police station, has been a fixture on Indiana Avenue for over 100 years. (Photo courtesy of Lanette Mullins.)

Every spring the "downtown hotdog stand" becomes a fixture on Lincolnway. Seen here, Amy White, representative of Midwest Amusements and Concessions, sells hotdogs at lunchtime to downtown visitors. (Photo courtesy of Lanette Mullins.)

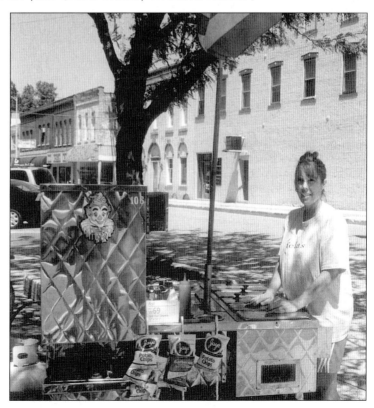

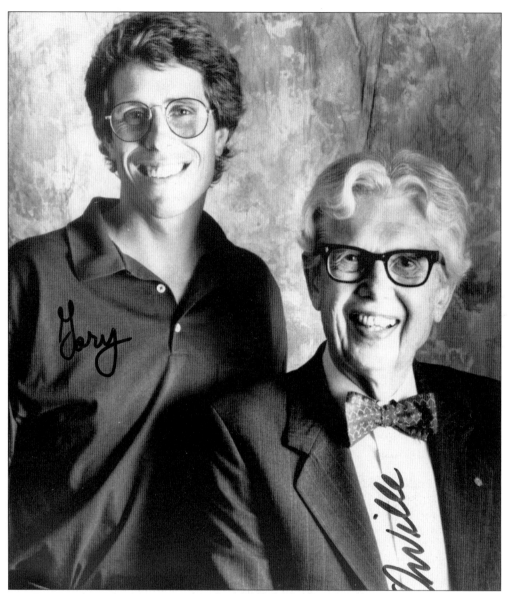

Orville Redenbacher, seen here with grandson Gary, was born in 1907 in Brazil, Indiana, and has a long and wonderful history with the City of Valparaiso. When he was 12 years old, he started producing popcorn and sold it to nearby stores. Thus, began his fascination with popcorn. Orville graduated from high school with honors in 1924. He attended Purdue University where he studied agriculture and further explored popcorn. He received a BA in 1928. By 1936, Orville and family were already living in Valparaiso, where he and his partners consolidated and settled their seed and grain company, but Orville couldn't give up popcorn. By 1959, Carl Hartman joined the company and changed everything by simply letting the wind pollinate the corn. With the help of Mother Nature, in 1965, Orville's dream came true. After 40 years of research, the trademark Redenbacher popcorn was created: light and fluffy, with hardly any unpopped kernels, few hulls, excellent taste, the popcorn exceeded previous standards with a 44 to 1 ratio of popped to unpopped corn. (Photo courtesy of Valparaiso Community Festivals & Events, Inc.)

Valparaiso's Annual Popcorn Festival began in 1979 to which Orville was a regular visitor. A main feature of the festival is the popcorn parade. Valparaiso's popcorn parade is unique because it is the only parade in the country where all the floats must be made of popcorn. A different theme each year makes for wonderful floats and lots of fun. (Photo courtesy of Valparaiso Community Festivals & Events, Inc.).

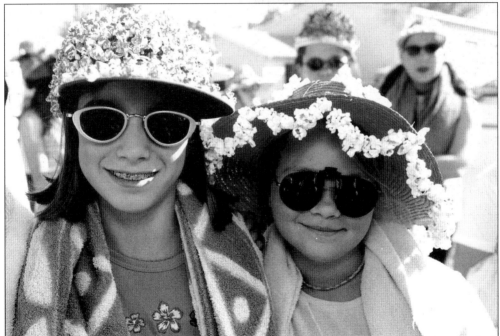

The festival draws tens of thousands of visitors. It hosts events and activities for adults and children alike. Seen here, two young girls display their popcorn-covered hats. (Photo courtesy of Valparaiso Community Festivals & Events, Inc.)

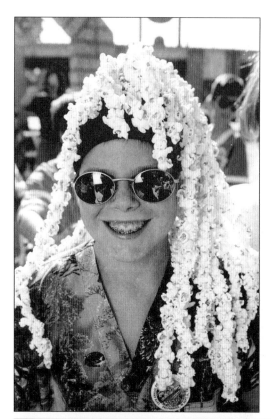

The festival is a time for everyone to enjoy the last days of summer. This young boy has made the most of the festival. His popcorn wig is stylish and edible. (Photo courtesy of Valparaiso Community Festivals & Events, Inc.)

Anneliesje's Bagels has become one of Valparaiso's favorite cafes. Located on Lincolnway in downtown Valparaiso, Anneliesje's specializes in espresso and espresso drinks from Anneliesje's special blend. The outside seating area is a wonderful place to sit and enjoy good food, fabulous espresso, and the company of friends. (Photo courtesy of Lanette Mullins.)

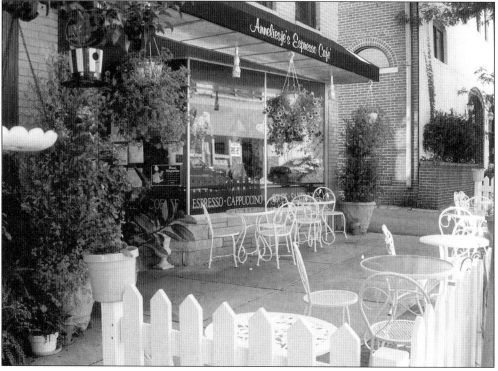

Don Quijote's, owned by Carlos Rivero and Elena Jambrina, opened in 1985. Offering authentic Spanish cuisine, house specials include tapas (appetizers) and paella (saffron rice with seafood). Don Quijote's is perfect for family dining. (Photo courtesy of Lanette Mullins.)

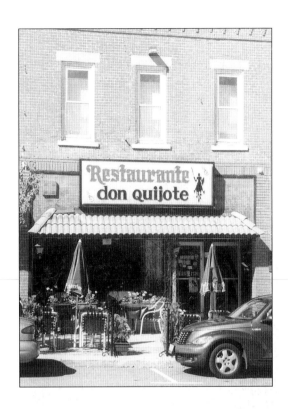

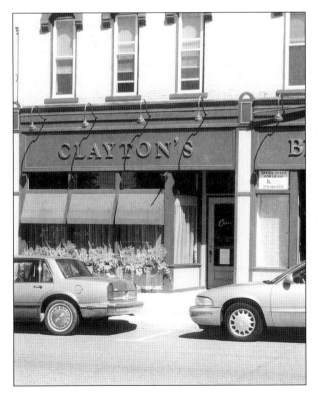

Claytons's offers fine dining in an elegant atmosphere. Its menu features a variety of wonderful dishes to suit everyone's taste. (Photo courtesy of Lanette Mullins.)

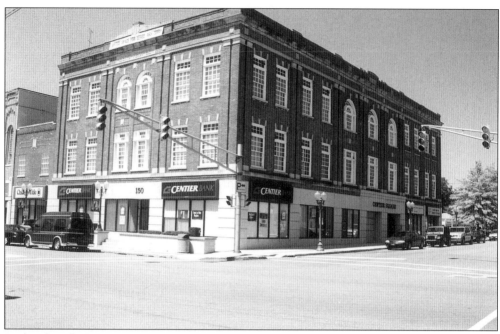

Today the Elks Temple site is known as 150 Lincoln Square and houses Centier Bank and the Valparaiso Chamber of Commerce. (Photo courtesy of Lanette Mullins.)

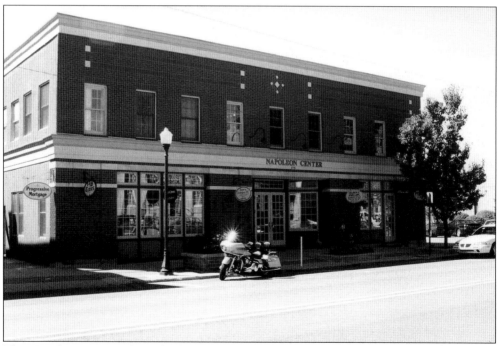

The Napoleon Center, formerly the home of the *Vidette Messenger* newspaper, houses several small firms and Pass Times. (Photo courtesy of Lanette Mullins.)

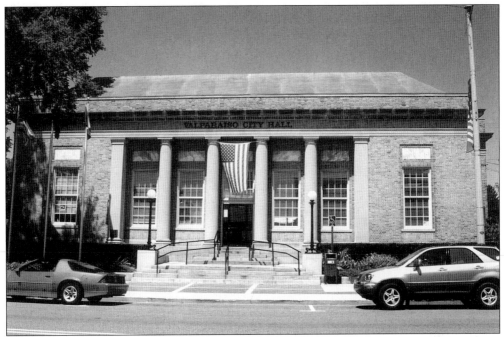

Valparaiso City Hall is the center of city government. When the building was renovated in 1988, a time capsule was found containing photos, letters, and catalogues from 1918. Mayor David A. Butterfield and City Clerk-Treasurer Sharon Emerson Swihart maintain the capsule collection. (Photo courtesy of Lanette Mullins.)

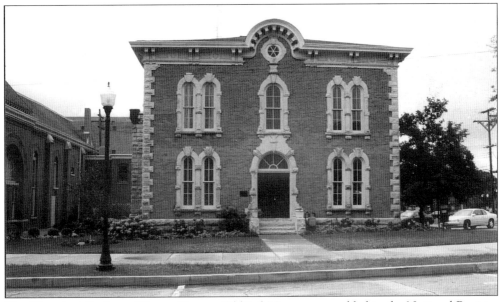

The Historical Society of Porter County–Old Jail Museum was added to the National Register of Historic Places in 1976. Today the museum offers visitors a glimpse into the past. The interior of the sheriff's residence looks much as it did 100 years ago. In what were once the prisoner's cells, today are displays of the county and city's history. (Photo courtesy of Lanette Mullins.)

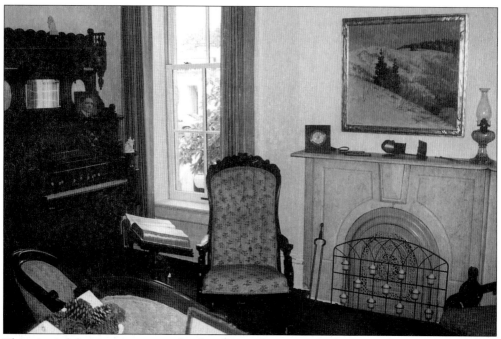

This view of the sitting room in the sheriff's residence captures what life must have been like at the turn of the 20th century. The organ in the corner was locally made. (Photo courtesy of Lanette Mullins.)

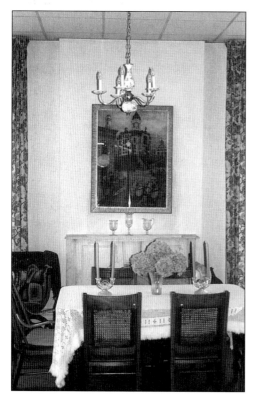

The sheriff's residence, with its comfortable dining room seen here, sharply contrasts the conditions of the prisoners, who were just a few hundred feet away. (Photo courtesy of Lanette Mullins.)

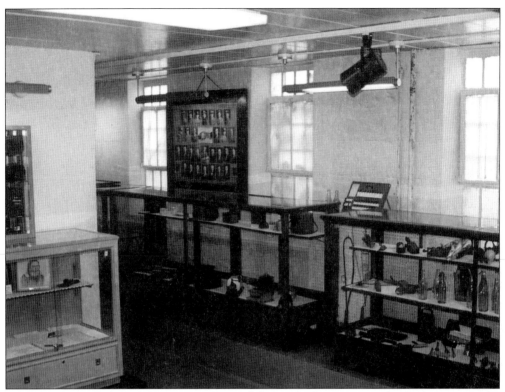

The prisoner's cells have been converted into different displays. Among the displays are articles belonging to "Bronco John," the death mask of Clarence Easton, a collection of canon balls found in tree trunks, and antique equipment from a dentist's office. (Photo courtesy of Lanette Mullins.)

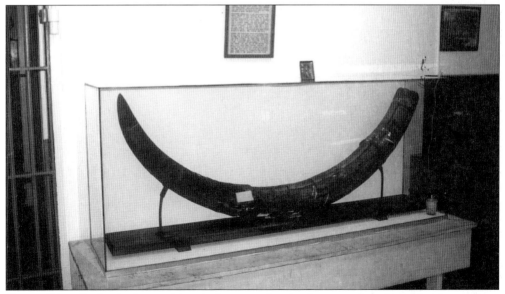

One striking display is the pre-historic bones and tusk of a mastodon. Mastodon bones have been found throughout northwest Indiana. This evidence, and other such artifacts, proves that these enormous creatures once lived in this area. (Photo courtesy of Lanette Mullins.)

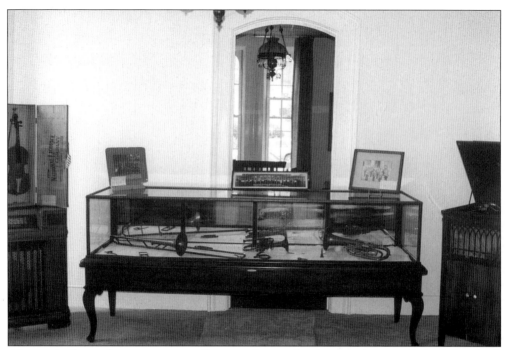

Also on display in the museum is a collection of musical instruments, many of which date back to the late 1800s. (Photo courtesy of Lanette Mullins.)

The Memorial Opera House was listed on the National Register of Historic Places in 1984. In 1998, the Opera House was restored to its Victorian splendor. The building's red, white, and blue stained-glass windows and the plaque over the door reflect the Grand Army of the Republic's patriotic vision. (Photo courtesy of Lanette Mullins.)

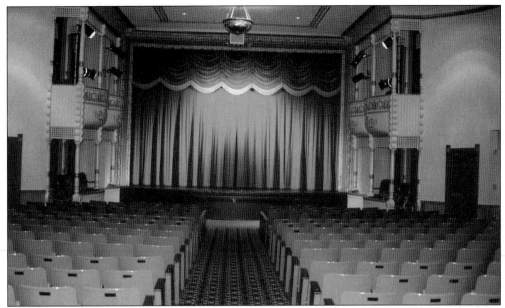

The restoration, sponsored in part by proceeds from the sale of commemorative bricks, located in the sidewalk in front of the building, has returned the Opera House to its former beauty. (Photo courtesy of Memorial Opera House.)

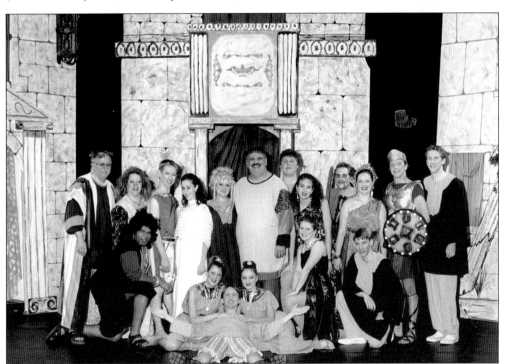

The Memorial Theatre Company puts on six shows a year. Here we see the cast of November 2001's, *A Funny Thing Happened on the Way to the Forum*. The Opera House also hosts three community band concerts and a variety of other events, ranging from weddings to graduations. (Photo courtesy of Memorial Opera House.)

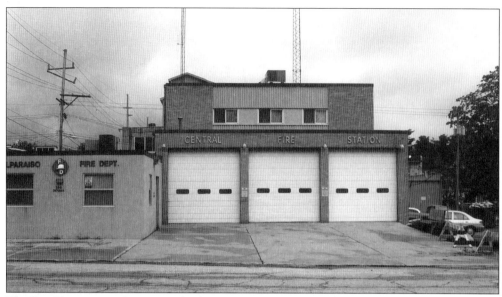

The Fire Department, Station 1, also known as Central Fire Station, moved to its current home on Indiana Avenue, near Morgan Boulevard, c. 1963–4. (Photo courtesy of Lanette Mullins.)

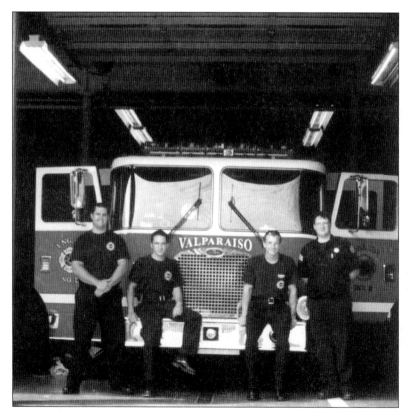

Since September 11, 2001, firemen have become national heroes. Pictured from left to right are four of Valparaiso's heroes, Mike Szany, Don Edgecomb, Jack Johnson, and Scott Stafford. (Photo courtesy of Lanette Mullins.)

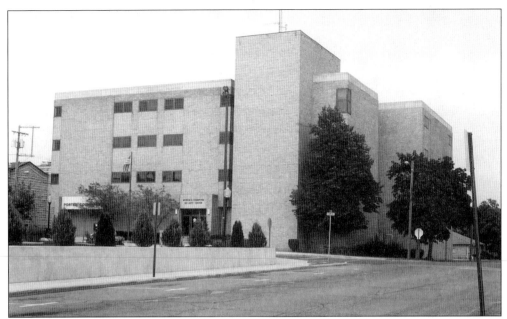

The Porter County Sheriff's Department was started in 1836. In 1974, The Sheriff's Department moved from the old jail and sheriff's residence, down the block to its present location. In 2002, the Sheriff's Department will move to its new location located on Highway 49. (Photo courtesy of Lanette Mullins.)

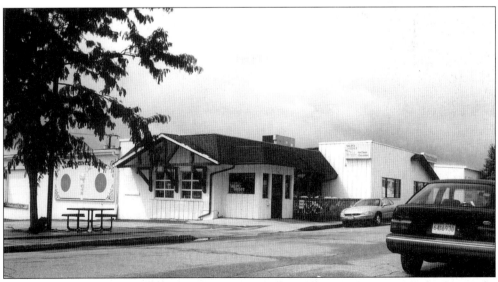

Brown's, a family-owned business, has made Valpo Velvet Ice Cream a staple dessert for Valparaiso. (Photo courtesy of Lanette Mullins.)

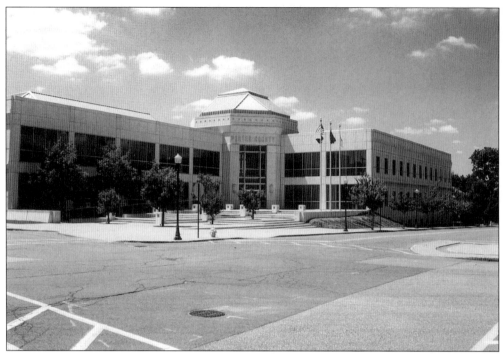

The Porter County Administration Center was built *c.* 1995 and is located on Indiana Avenue. The building houses all the government offices of Porter County. (Photo courtesy of Lanette Mullins.)

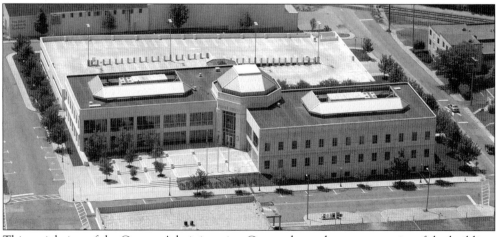

This aerial view of the County Administration Center shows the enormous size of the building. (Photo courtesy of Brad Cavanaugh, Air One Inc.))

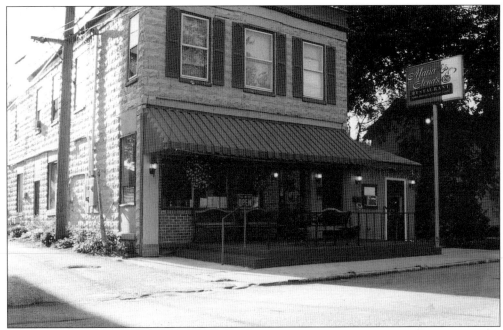

Maria Elena's Restaurant, located on Greenwich Street, one block north of the School of Law, is a favorite for Valparaiso University faculty, staff, and students. It offers fine dining, pleasant service, and an extensive menu. (Photo courtesy of Lanette Mullins.)

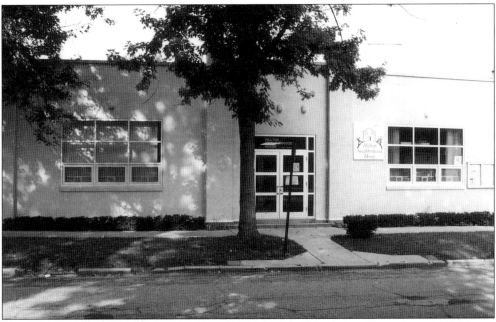

Also located near the School of Law on Locust Street, is Hilltop Neighborhood House and Hilltop Community Health Center. The center opened in 1996 and provides health care for those with no other access to treatment, affordable childcare, and neighborhood empowerment, which has helped the community to create a neighborhood association, a park, and a food pantry. (Photo courtesy of Lanette Mullins.)

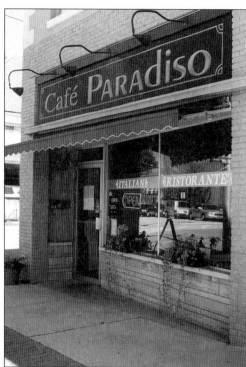

Café Paradiso opened in 1999. Owned by Fonnie Duron and Saverio Castellucci, the charming café offers authentic Italian cuisine. The house special is homemade cannoli. (Photo courtesy of Lanette Mullins.)

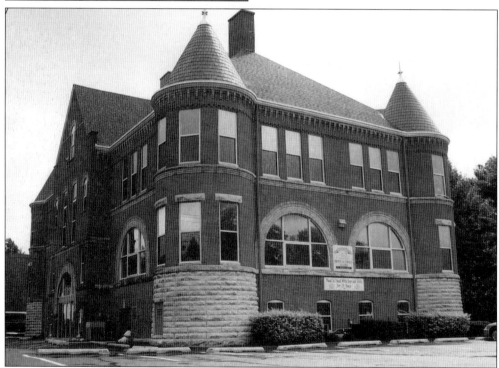

The Boys and Girls Club of Porter County purchased the Gardner School building in 1972 to house its Valparaiso programs. The club offers a variety of activities for Porter County's youth in addition to awareness programs. (Photo courtesy of Lanette Mullins.)

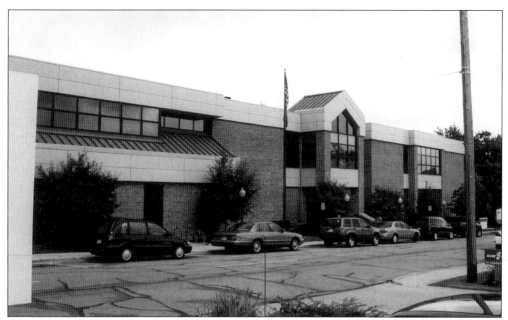

The Valparaiso Public Library began in 1838. Its first location was in the former home of Hubbard and Finnette Hunt on Washington Street. The second library was built in 1916 with the help of a grant from the Carnegie Corporation. The third and present library, located on Jefferson Street, was completed in 1980. (Photo courtesy of Lanette Mullins.)

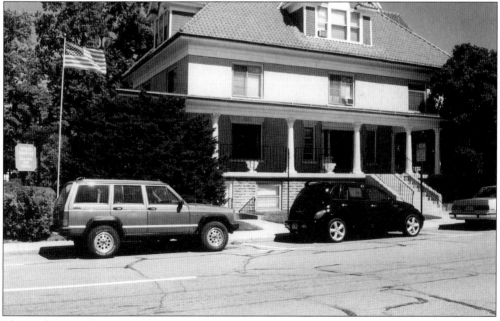

The Valparaiso Women's Club dates to before 1895. In 1896, the group of women named themselves the Harriet Beecher Stowe Club. During Sarah Porter Kinsey's presidency, the name was changed to Valparaiso Women's Club. The club is presently housed in Dr. David J. Loring's residence and clinic. The building was placed on the National Register of Historic Places in 1984. (Photo courtesy of Lanette Mullins.)

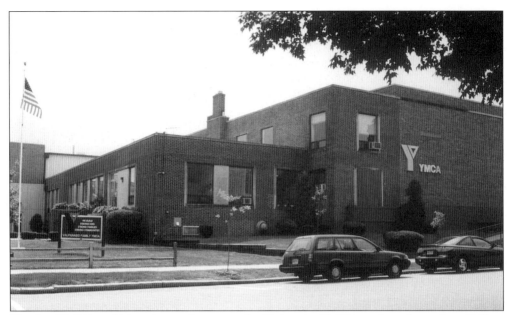

The first YMCA in Valparaiso was known as the University YMCA and was located on College Avenue. The YMCA acquired its current location in 1951, at the corner of Washington and Chicago Streets. The facility, which has undergone several expansions, has a pool, a large assortment of exercise equipment, and activities for children and adults. (Photo courtesy of Lanette Mullins.)

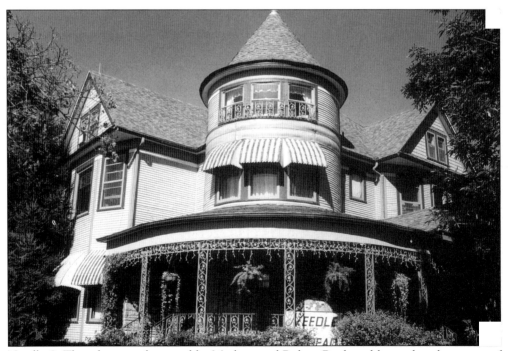

Needle & Thread, currently owned by Marleen and Robert Rock and located at the corner of Lafayette and Chicago Streets, is a sewing, crafts, and supply boutique. The Victorian-style building dates to c. 1900. (Photo courtesy of Lanette Mullins.)

The Chicago Street Theater was built as the Assembly of God Church in 1950. Today, the theatre puts on several performances each year. (Photo courtesy of Lanette Mullins.)

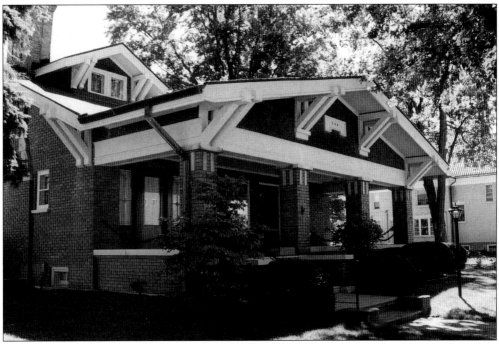

Charles Lembke designed the home of Mrs. Rolb Pool. Built in 1912 in the Chicago Bungalow style, it has a spacious interior and original leaded stained-glass windows. (Photo courtesy of Lanette Mullins.)

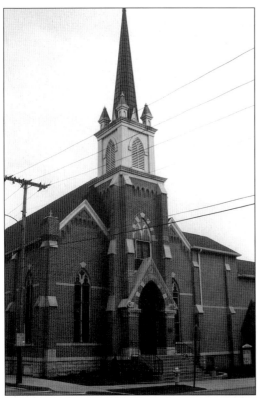

Built in 1891, Immanuel Lutheran Church, now Heritage Lutheran Church, was added to the National Register of Historic Places in 1982. The church was rebuilt in 1975 after a fire severely damaged the building. (Photo courtesy of Lanette Mullins.)

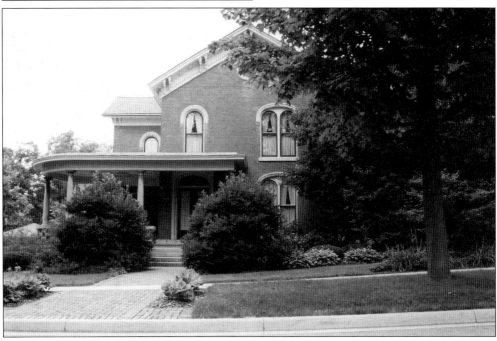

The home of Fred and Clarice Frey, the former home of Andrew Jackson Buel, was built in the 1850s. The home maintains its original coach house and beautiful landscaping. (Photo courtesy of Lanette Mullins.)

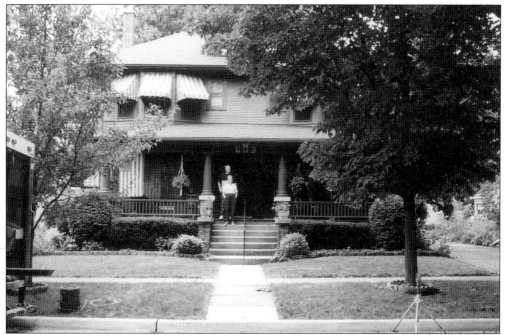

This American Foursquare, belonging to Warren and Sharon Crowder, was built in 1903. The Foursquare was the most house for its worth after the Victorian style. The house is very symmetrical. Originally the house had a veranda that wrapped around the front, which was a way to associate with one's neighbors without having to invite them into your home. (Photo courtesy of Lanette Mullins.)

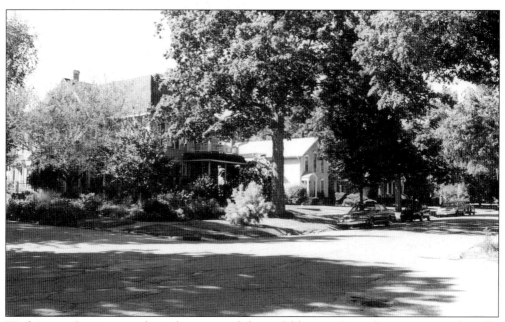

Washington Street is not the only street with beautiful homes. Several streets surrounding the historical downtown have such homes. Seen here is a view down Lafayette Street. (Photo courtesy of Lanette Mullins.)

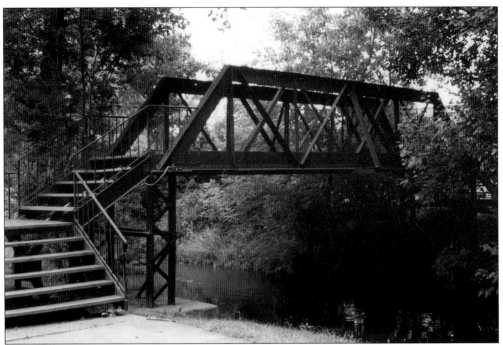

When Lover's Repose Bridge was torn down in the 1960s, part of it was saved and now crosses Salt Creek next to the Vineyard Christian Fellowship Church, just off of US 30. (Photo courtesy of Lanette Mullins.)

Kirchhoff Park is an 11-acre park and is located on Roosevelt Road. It was Valparaiso's first public park, donated by Frederick Kirchhoff, and marked the beginning of Valparaiso's Park Department. Today, the Park Department maintains over 600 acres of land. (Photo courtesy of Lanette Mullins.)

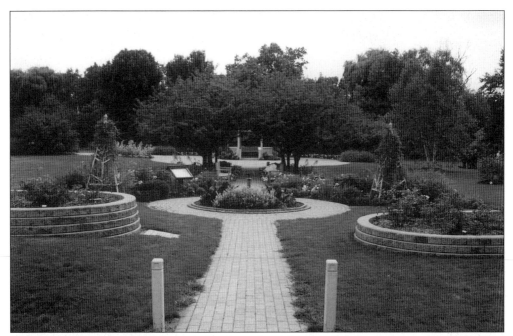

Ogden Gardens, located on Harrison Boulevard and Campbell Street, was bought in 1948 and is thought by many to be the loveliest park in the city. The gardens cover 10 acres of land. (Photo courtesy of Lanette Mullins.)

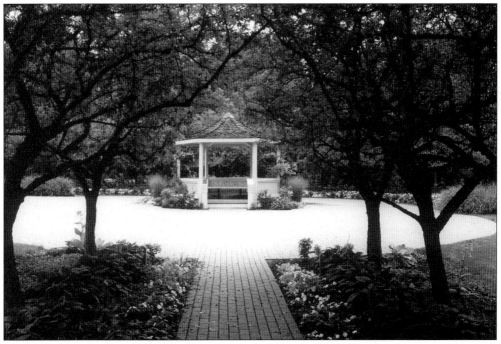

Ogden Gardens has become a popular place to hold weddings. With the charming colonnade of trees and gazebo, it is easy to see why it is a favorite among young brides. (Photo courtesy of Lanette Mullins.)

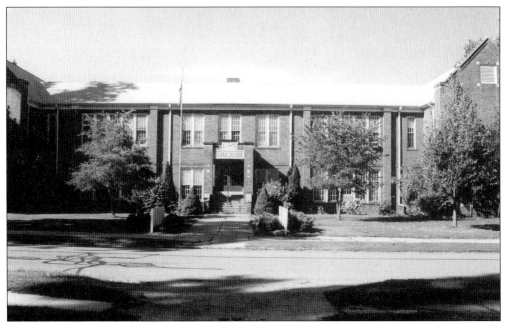

The Banta Activities Center on Beech Street was purchased from the Valparaiso Community Schools in 1983 and covers two acres of land. (Photo courtesy of Lanette Mullins.)

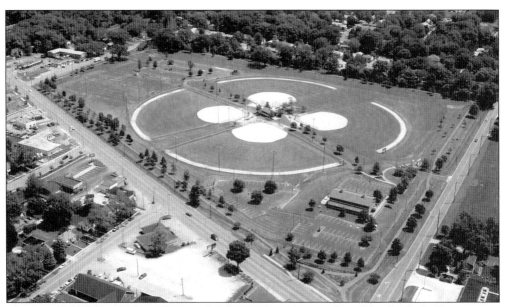

Fairgrounds Park, located on Evans and Calumet Avenues, was leased by the Parks Department in 1985 and is a 27-acre, multi-recreational area. This aerial photo shows the four baseball diamonds in the center of the park, which looks like a four-leaf clover. (Photo courtesy of Brad Cavanaugh, Air One Inc.)

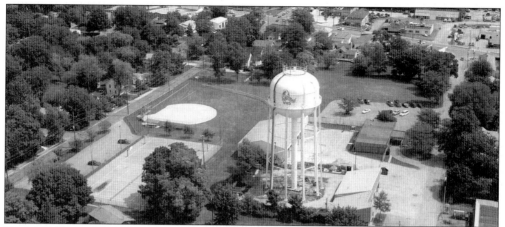

Tower Park, on Evans Avenue, was purchased in 1959. The park gets its name from the water tower, which bears the Valparaiso High School's Viking mascot. The park covers five acres of land. (Photo courtesy of Brad Cavanaugh, Air One Inc.)

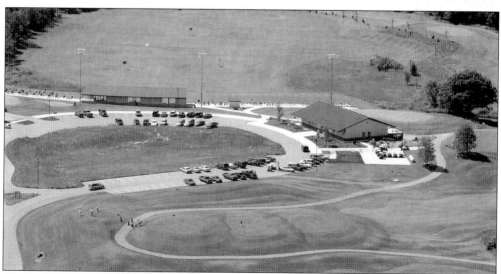

Creekside Golf Course, formerly the Johnson Farm and purchased in 1992, is open to the public and offers 18 holes of golf. The golf course covers 75 acres of developed land. (Photo courtesy of Brad Cavanaugh, Air One Inc.)

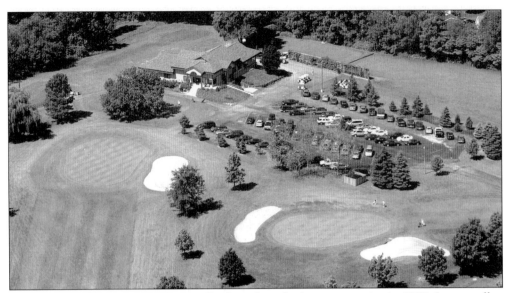

Forest Park Golf Course on Harrison Boulevard reached its current size in 1973. It, too, offers 18 holes of golf and is open to the public. The golf course covers 125.7 acres of land. (Photo courtesy of Brad Cavanaugh, Air One Inc.)

The land on which Rodgers-Lakewood Parks, located north of the city, sits attained its present size in 1967. The park offers a variety of activities. (Photo courtesy of Brad Cavanaugh, Air One Inc.)

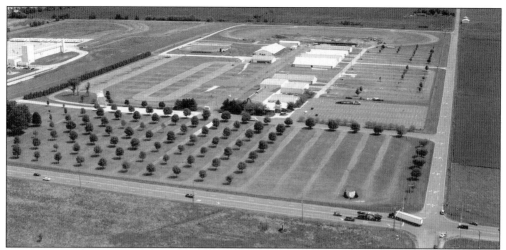

The current Porter County Fair Grounds lies outside the city limits. The fairgrounds, located on Highway 49, cover several acres, and in July, the Porter County 4-H fair attracts visitors from all over the county to partake of the fun. (Photo courtesy of Brad Cavanaugh, Air One Inc.)

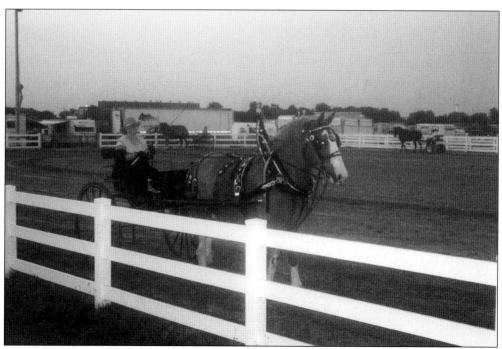

As part of the animal exhibition, Dr. Bloom and "Snickers" take part in the Draft Horse Show. (Photo courtesy of Nina Corazzo.)

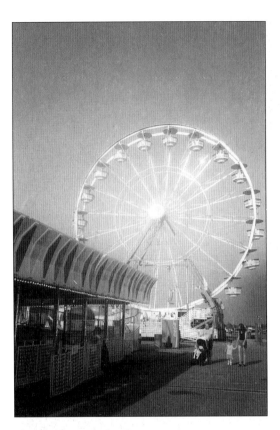

A major part of any fair is the Ferris wheel, which can be enjoyed by the child in us all. As usual, it was a favorite at the 4-H fair. (Photo courtesy of Nina Corazzo.)

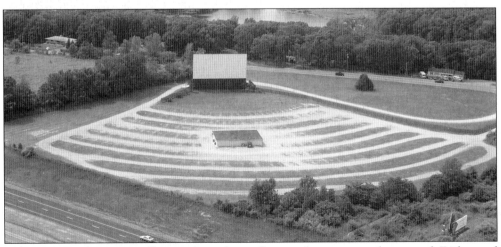

Valparaiso residents, as well as citizens from all over the county, often spend Friday and Saturday nights during the summer at the 49er Drive-In Theatre, located on north Calumet Avenue. (Photo courtesy of Brad Cavanaugh, Air One Inc.)

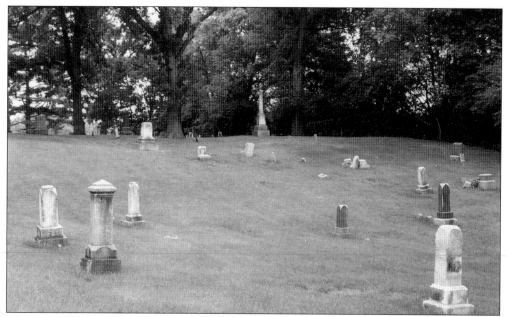

Though an unusual feature and one that always elicits solemnity, Valparaiso has four cemeteries. The oldest cemetery in Valparaiso is Union Street Cemetery. It has many graves belonging to the city's founders. Unfortunately, due to vandalism, the cemetery is closed to the public and is kept locked in order to preserve the site. (Photo courtesy of Lanette Mullins.)

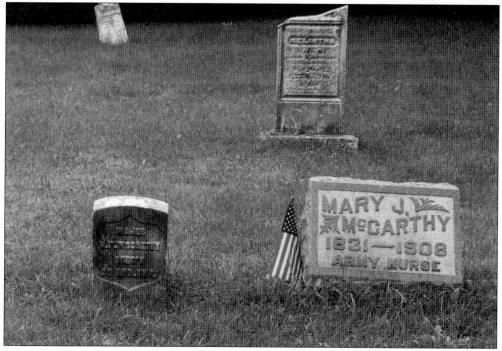

Union Street Cemetery was the site for many Civil War burials. The stone on the left is for a Major who was in the Indiana Infantry. The stone on the right is for Mary McCarthy, a Civil War Army nurse. (Photo courtesy of Lanette Mullins.)

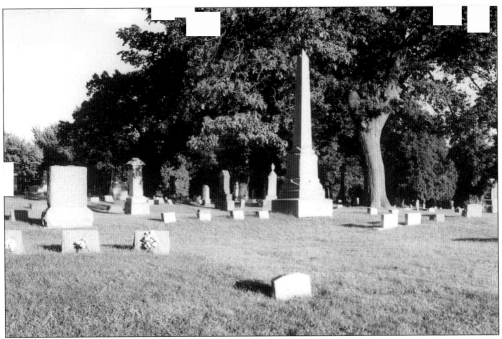

Maplewood Cemetery is on the north side of Graceland Cemetery. This cemetery, too, is the final resting site for many of Valparaiso's famous citizens. (Photo courtesy of Lanette Mullins.)

Graceland Cemetery, next to Highway 30, is an example of an interesting phenomenon. Nearest Maplewood Cemetery, there are traditional standing head stones. Nearest the highway, the headstones are embedded in the earth. This has been done for maintenance reasons. (Photo courtesy of Lanette Mullins.)

Memorial Cemetery, located on Highway 2, is the only cemetery in the city open for new burials. (Photo courtesy of Lanette Mullins.)

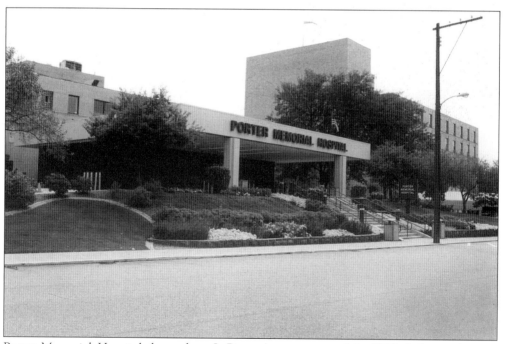

Porter Memorial Hospital, located on LaPorte Avenue, opened in 1939. It has undergone several renovations, the last in 1992. Hospital services include cardiovascular services, trauma treatment including a helicopter pad on its roof for air transport, and a newborn intensive care unit. (Photo courtesy of Lanette Mullins.)

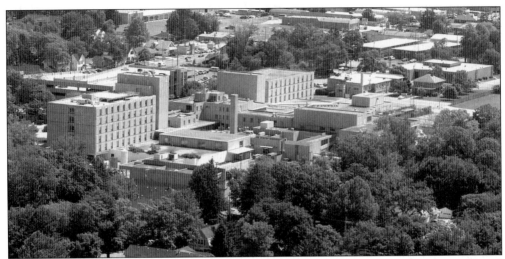

As seen from the air, Porter Memorial Hospital is a large facility that offers personal and professional care. (Photo courtesy of Brad Cavanaugh, Air One Inc.)

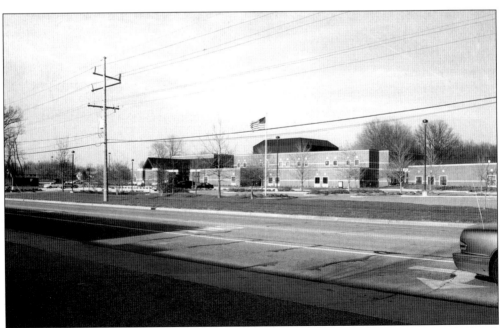

The Valparaiso Surgery Center of Porter Memorial Hospital, located on Roosevelt Road, opened in 1994. The facility specializes in ambulatory surgery, diagnostic imaging, mammography, ultrasound, and laboratory work. It is also the Northern Indiana Heart Center and Professional Offices. (Photo courtesy of Lanette Mullins.)

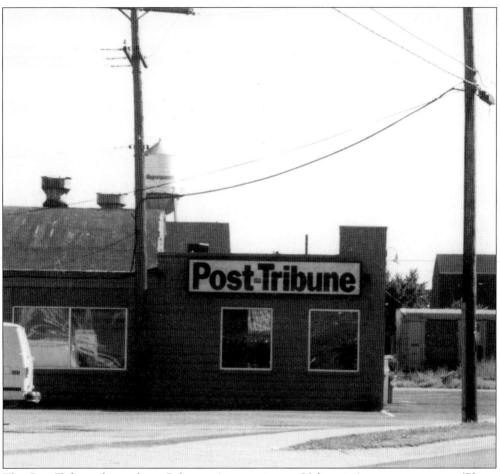

The *Post-Tribune*, located on Calumet Avenue, is one Valparaiso's two newspapers. (Photo courtesy of Lanette Mullins.)

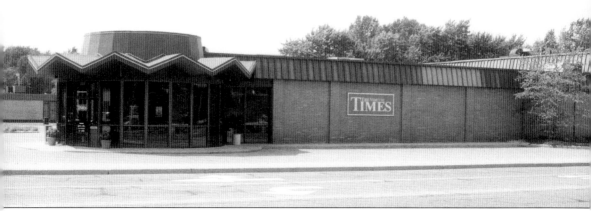

Known today as the *Vidette Times*, the *Vidette Messenger* was the consolidation of two newspapers by Lynn Whipple. Originally on the site of the present Napoleon Center, the newspaper moved to its current location on Roosevelt Road in 1972. In 1995, the newspaper became the *Vidette Times* and in 2002 the newspaper was bought by Lee Enterprises. (Photo courtesy of Lanette Mullins.)

Four

GROWTH OF A CITY

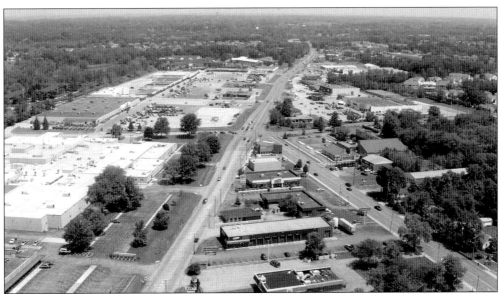

The City of Valparaiso has grown significantly in the past 20 years. The northward expansion of the city along Calumet Avenue and Roosevelt Road has created a new business district. From the air we can see the five-way stop at the triangular junction of Calumet Avenue and Roosevelt and Vale Park Roads. Further north, Calumet Avenue is lined with businesses, department stores, and restaurants. (Photo courtesy of Brad Cavanaugh, Air One Inc.)

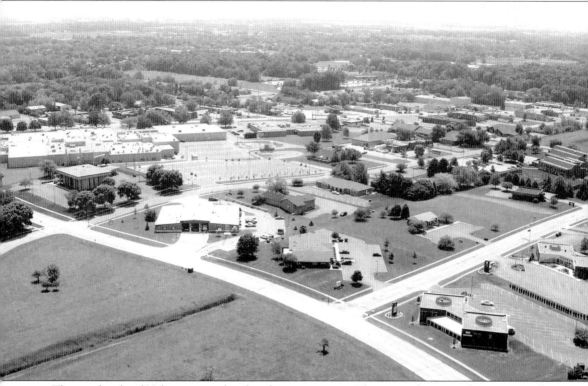

The north side of Valparaiso is a bustling business center. The area is home to three strip-mall complexes. The north side is also home to the County Seat Cinema, which has six theatres. The restaurants in the area range from fast food to ethnic, such as Mexican and Chinese. Billy Jack's Café & Catering and Pesto's Italian Cuisine offer delicious food and fine dining. The area between Vale Park Road, Calumet Avenue, Glendale Boulevard, and Valparaiso Street is a commercial and professional center. The area has a very modern feeling and is home to several small firms, professional offices, pre-schools, a Goodwill Store, Valparaiso Fire Department, Station 2, Urschel Laboratories, a U.S. Post Office, Ivy Tech State College, and Purdue University North Central—Valparaiso Academic Center. The growth of the city also spreads northeast and northwest. Northeast of Calumet Avenue is primarily residential, while northwest of Calumet Avenue is a mix of residential and commercial sites. (Photo courtesy of Brad Cavanaugh, Air One Inc.)

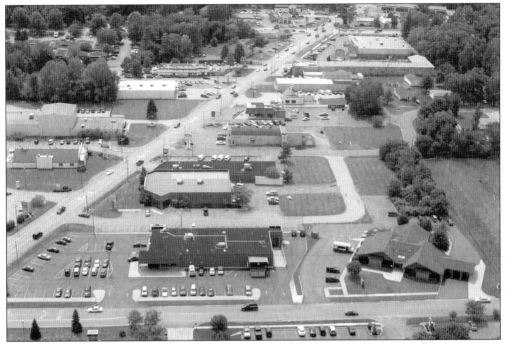

With the number of professional offices such as attorneys, medical doctors, dentists/orthodontists, as well as many other small businesses, Calumet Avenue is busy all day long. Seen here at Wall Street, Calumet angles into Glendale Boulevard. (Photo courtesy of Brad Cavanaugh, Air One Inc.)

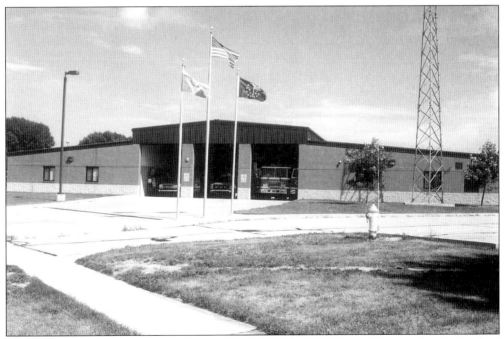

The Valparaiso Fire Department, Station 2, was built in 1994 to meet the growing demands of the city. (Photo courtesy of Lanette Mullins.)

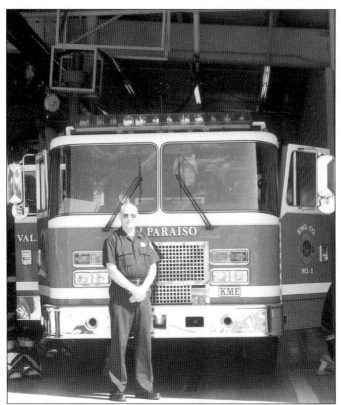

Willie Hall, a senior fire fighter at Station 2, will soon retire from the department. His years of honorable service and heroism are greatly appreciated by the entire Valparaiso community. (Photo courtesy of Lanette Mullins.)

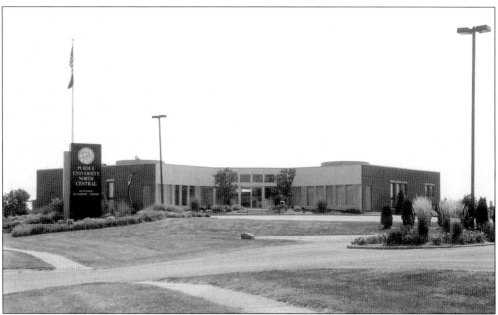

Purdue University North Central—Valparaiso Academic Center, located on Valley Drive, was established in 2000. It is a branch of Purdue University's Westville campus and offers general and basic education classes to degree-seeking students as well as management and technical professionals. (Photo courtesy of Lanette Mullins.)

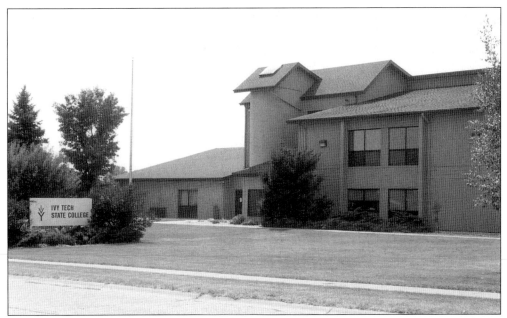

Ivy Tech State College, also located on Valley Drive, has been serving Porter County since 1968. The college offers a variety of classes such as practical nursing, accounting, electronics and technology, and general education. Ivy Tech recently acquired 26 acres in Eastport Industrial Park where it will build a 170,000-square-foot campus that will have state-of-the-art technology throughout the building. (Photo courtesy of Lanette Mullins.)

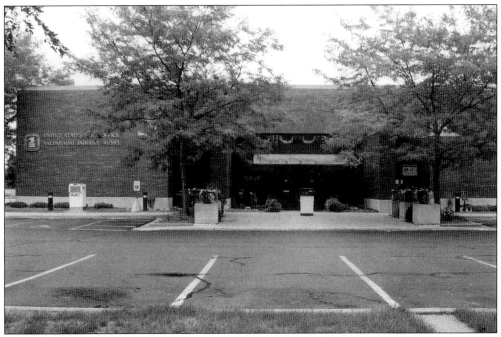

The U.S. Post Office is located on Valparaiso Street. The building was constructed c. 1987–88. It was formerly located in the present city hall, which still houses a branch that serves the downtown area. (Photo courtesy of Lanette Mullins.)

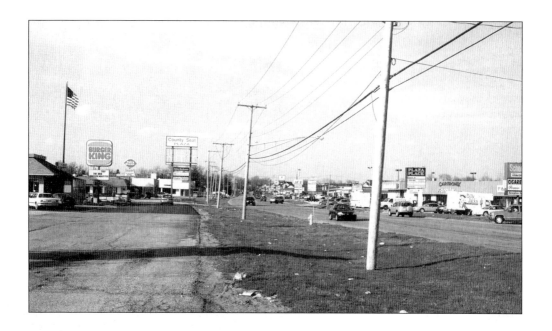

Looking again at Calumet Avenue north (top) and south (bottom) we see that the avenue is lined with businesses and shops. As one of the larger thoroughfares of the city, it is also subject to heavy traffic from local businesses, especially at noon and five o'clock. Many of Valparaiso's residents feel excess traffic is a significant detriment to the growth of the city. (Photo courtesy of Lanette Mullins.)

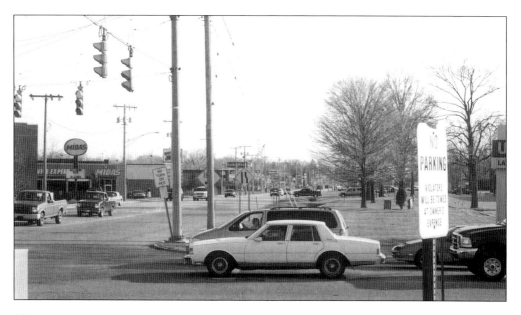

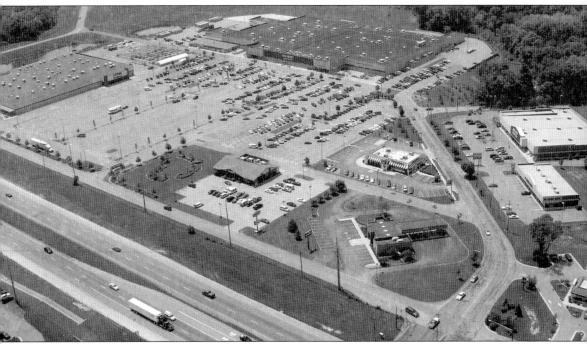

Valparaiso is also growing east and west. Since the early 1980s, businesses have more than doubled along US 30. The Wal-mart Super Center opened in 1990. A Wal-mart store had been on the site since the 1980s. The Super Wal-mart is a combination of a supermarket and department store. Today the store employs about 500 workers and the one-stop shopping attracts customers from many neighboring communities and counties. The old Wal-mart store was converted into a theater, but it closed after two years. The building now stands vacant. The Wal-mart plaza continues to grow because the site is easily accessed from US 30, which runs directly in front of the plaza. This, as well as the expansion of the city, has drawn several businesses such as Denny's, Taco Bell, Staples, The Shoe Dept., Sears, and Steak-N-Shake to the location. (Photo courtesy of Brad Cavanaugh, Air One Inc.)

The Thrum family started the Strongbow Inn in 1940. They raised their own turkeys and opened a small diner and inn in 1940. By the 1960s, the restaurant was famous for its turkey meat. The hotel was sold to Hampton Inns, but the restaurant retained the Strongbow Inn name. The restaurant continues to grow with its most recent expansion in 2002. (Photo courtesy of Lanette Mullins.)

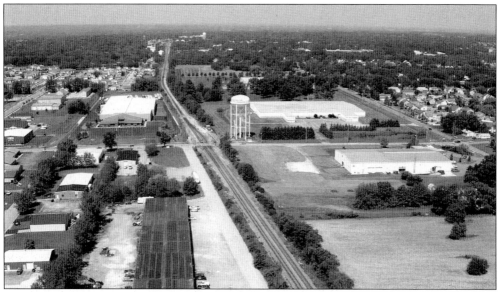

The area around Evans Avenue and Silhavy Road has also become an industrial, commercial, and residential center. In this photograph, looking west, we see the expanse of the industrial sites and their smooth transition into the residential areas nearby. Continue south on Silhavy Road and you will see the recently constructed professional offices that line the west side of the road. (Photo courtesy of Brad Cavanaugh, Air One Inc.)

The water tower on Silhavy Road reads, "Valparaiso, Home of the Crusaders," in support of Valparaiso University's Athletic Teams. In Tower Park, the water tower is painted with the Valparaiso High School's Viking mascot. (Photo courtesy of Brad Cavanaugh, Air One Inc.)

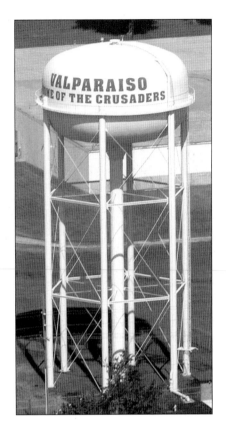

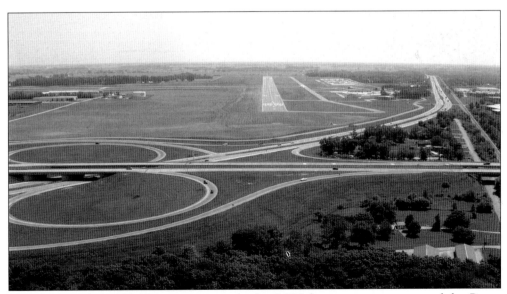

Looking east along US 30, we see not only the 7,000-foot, east-west runway of the Porter County Municipal Airport, but also the Eastport Centre for Commerce and Industry and Montdale Industrial Park. Both sites are within city limits. (Photo courtesy of Brad Cavanaugh, Air One Inc.)

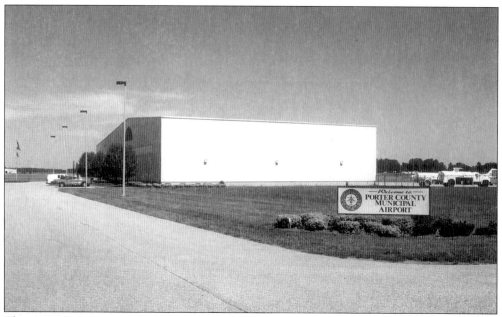

The airport's present terminal was built *c.* 1988. The airport is a common stop for many famous performers on their way to Merrillville's Star Plaza. (Photo courtesy of Lanette Mullins.)

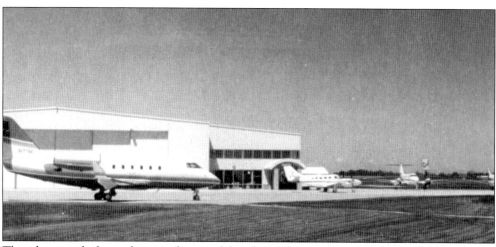

This photograph shows the size of some of the planes that use the airport on a daily basis. The airport is able to handle business jets including 737s, 727s, and DC-9s. (Photo courtesy of Porter County Municipal Airport.)

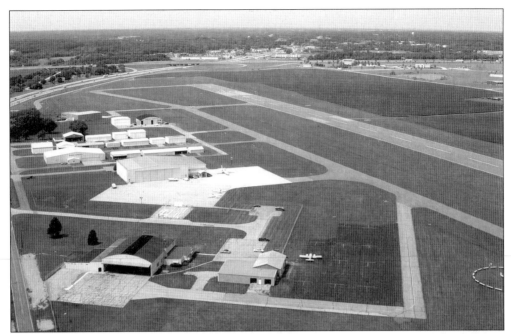

This aerial photograph shows the present size of the airport. The airport has become identified with the city because of its proximity. Much of the land surrounding the airport lies within city limits. These sites, including several hangers at the airport, have become home to many businesses. (Photo courtesy of Brad Cavanaugh, Air One Inc.)

The airport caters to all types of aircraft including helicopters. (Photo courtesy of Brad Cavanaugh, Air One Inc.)

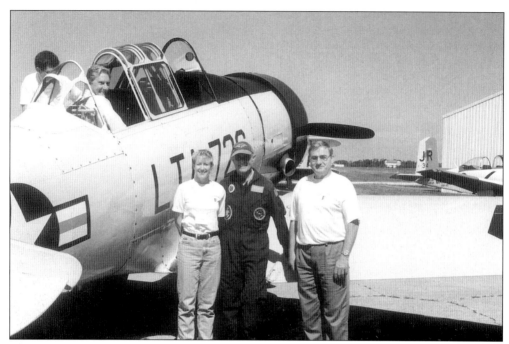

The airport is also home to the Indiana Aviation Museum, which opened in 2001. Museum President Jim Read, center, also owns a collection of eight "Warbirds." The museum is staffed by volunteers who are also licensed pilots with permission from the FAA to fly each type of plane. Cathy Harrell, left, is the only female pilot at the museum. (Photo courtesy of Lanette Mullins.)

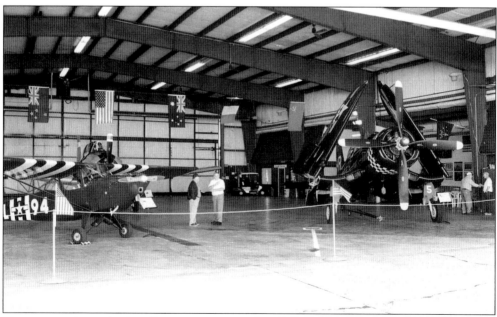

The museum's warbird collection consists of a P-51D "Mustang," T6 "Texan," PT17 "Stearman," T34B "Mentor," T28 "Trojan," BA1C "Strikemaster," "F 40-5 Corsair," and a L2 from the Army Air Corps. (Photo courtesy of Lanette Mullins.)

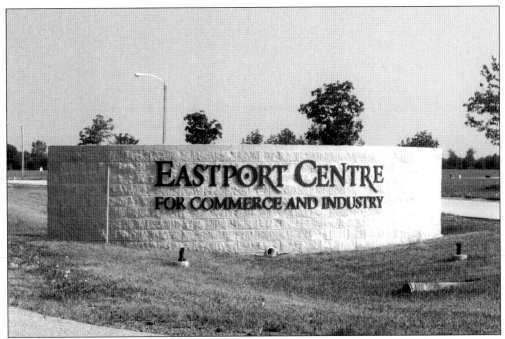

The Eastport Centre for Commerce and Industry is a new addition to the city. Many new companies have moved to the site. Natural Ovens, located on the north side of the complex, will soon begin production. Eastport is also the site for the new Ivy Tech building. (Photo courtesy of Lanette Mullins.)

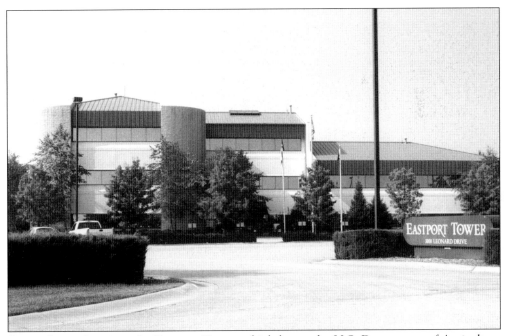

Currently on the site is the Eastport Tower, which house the U.S. Department of Agriculture for Porter County. On the west side of the building is a large water fountain that can be seen from US 30 and the 49 bypass. (Photo courtesy of Lanette Mullins.)

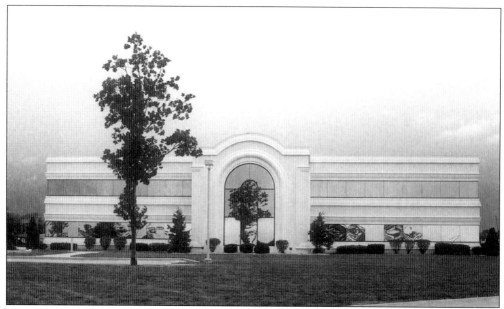

The Social Security Office for Porter County and several other firms are housed in this very modern building in the Eastport Centre. (Photo courtesy of Lanette Mullins.)

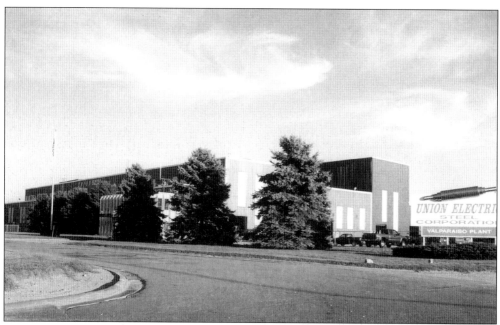

Valparaiso's Montdale Industrial Park, located off of US 30, is home to several of Valparaiso's larger factories. Union Electric Steel Corporation started in 1971. Its parent company, Ampco-Pittsburgh Corporation, was started in 1929 by Louis Berkman in Pittsburgh, Pennsylvania. Union Electric Steel makes forged hardened steel rolls for the metals finishing industry. Union Electric Steel is one of four in the United States and Europe. (Photo courtesy of Lanette Mullins.)

Another company in Montdale Industrial Park is Rexam Beverage Can. When Rexam bought the company in 2000, it was called American National Can and had been on the site since 1988. Rexam, the parent company, was founded in 1881 and started out in printing and packaging. Rexam makes the tops of aluminum beverage cans. (Photo courtesy of Lanette Mullins.)

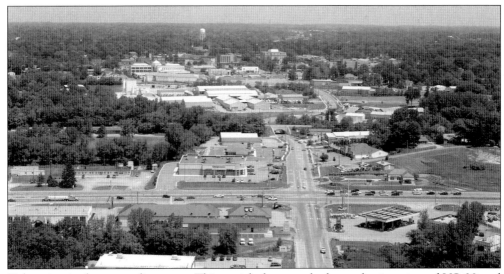

Valparaiso is also expanding west. This aerial photograph shows the junction of US 30 and Indiana Highway 2. This area has grown significantly in recent years. (Photo courtesy of Brad Cavanaugh, Air One Inc.)

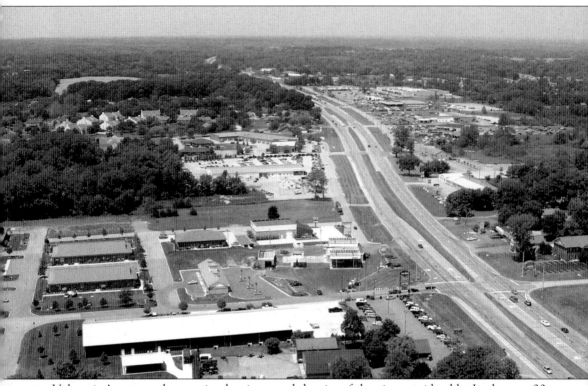

Valparaiso's westward expansion has increased the size of the city considerably. In the past 20 years, the number of businesses along US 30 has more than doubled. This is due in part to the number of motorists who use US 30 to get to Merrillville, and many of the businesses along the highway cater to motorists. Restaurants such as Applebee's have moved to the area because of the easy access for motorists. Other businesses moved, and continue to move, west because of the demand from new housing developments that are springing up along the highway. Several car dealerships occupy large spaces, but strip-malls for small business and a supermarket have also taken up residence in the area. Zao Island is also located on the highway, just past its Highway 2. The amusement park offers miniature golf, go-carts, batting cages, and arcade games. (Photo courtesy of Brad Cavanaugh, Air One Inc.)

Valparaiso University is also growing. A new university library is being built directly west of the chapel and across from Mollering Library. Construction on the Center for Library and Information started in the summer of 2002. The building will feature electronic classrooms, a full text electronic journal collection, networked study stations, and several computer clusters. The new structure will be four stories with 115,000 square feet of space for the library. The first floor will be the new home to the Electronic Services Help Desk, the Writing Center, a large reading room, a café, and a computer lab. The circulation desk will be on the second floor as well as the reference room, a high-tech classroom, a large community room, and a smaller Heritage Room, which will be a high-tech conference room. The third and fourth floors will be for the library stacks, offices, a faculty lounge, and group study rooms with direct access to the university's computers. The entire university is excited about the project and anxiously awaits its completion. (Photo courtesy of Lanette Mullins.)

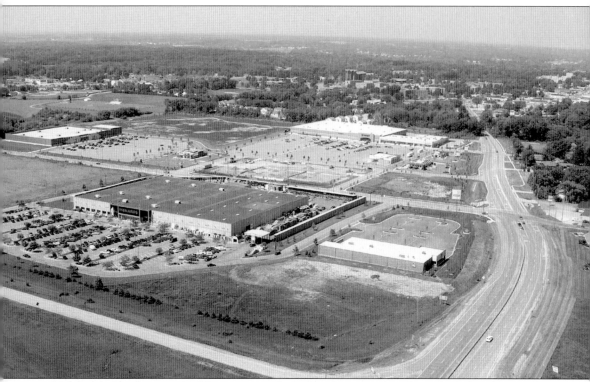

Valparaiso has become highly commercial in the past two decades, which has been very beneficial for the economy and for the community. New stores and businesses create jobs which, in turn, cause people to move to the city to be closer to their jobs. Valparaiso's newest commercial center, and first of the 21st century, is located on Indiana Highway 2. The large shopping mall consists of Target, Kohl's, several boutiques, restaurants, a grocery store, and is the future site of a Barnes & Noble book store. Though Menards, which was built in the 1990s, was the first store on the site, it is currently constructing a new, much larger facility next to its present store. The mall is very popular among the university's students, because of its proximity to the campus, city, and surrounding communities. (Photo courtesy of Brad Cavanaugh, Air One Inc.)

116

The construction for the new Menards' store is under way. The mall still has a great deal of undeveloped land that will surly be filled in the coming years. (Photo courtesy of Lanette Mullins.)

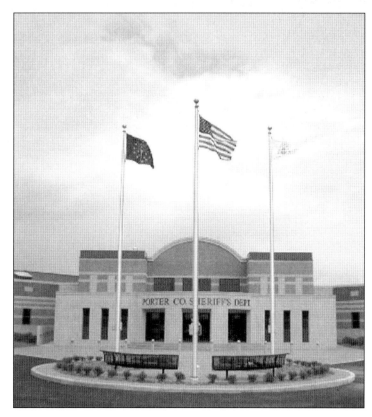

In mid-September 2002, the new Porter County Jail will open at its new location behind Montdale Industrial Park on Highway 49. (Photo courtesy of Christine Sears.)

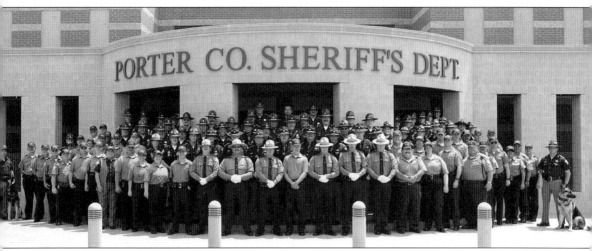

The entire Porter County Sheriff's Department stands in front of the new county jail. (Photo courtesy of Christine Sears.)

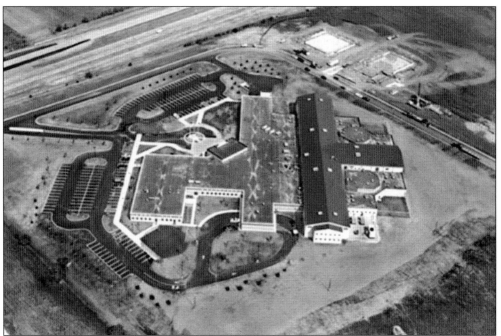

Though still within the city limits, when the new county jail opens in mid-September, it will be the first time in 166 years that the Sheriff's Department will not be located in downtown Valparaiso. The original county jail was built in 1836, the same year Porter County and the Sheriff's Department was founded. The county jail moved into what is today the Old Jail Museum, where it stayed until 1974, when the present county jail opened. The new county jail will double the space of the present jail. During planning and construction of the jail, a task-force team went to different jails across the country to find the most beneficial elements of each and interpret then into the design of the new jail. Currently, a transition team is working to ensure new standards and operations modes are met. (Photo courtesy of Christine Sears.)

Five
DOWNTOWN IN THE 21ST CENTURY

Valparaiso may be a large city that is constantly on the go, but it still retains an air of small town charm, and residents certainly appreciate the simple life. In this photograph, hot air balloons float in the sky as part of the Popcorn Festival Celebration. (Photo courtesy of Lanette Mullins.)

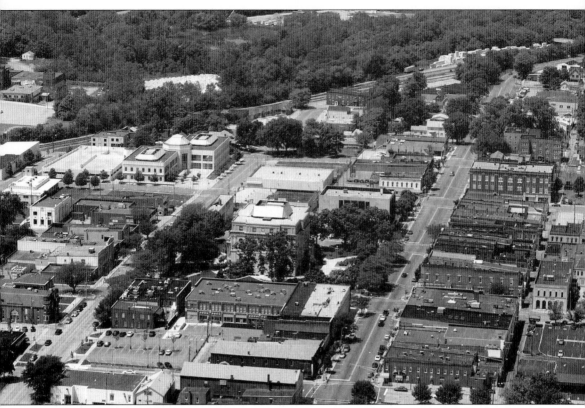

Valparaiso is a very modern city. The city has grown in every direction to meet the demands of the 21st century. Yet, for many, the downtown area is the heart of the city. As the city's historical representative in the new millennium, it retains an air of timeless grace and often feels like a small town within the larger, modern city. Yet, even as the downtown holds tightly to its past, it welcomes the future. Though the buildings may have remained the same, their tenants and owners have transformed the area in to a commercial, social, political, and cultural center. Through this process, the downtown has retained its history while growing economically. Residents appreciate the small town atmosphere when they come downtown to meet with friends, enjoy shopping, or eat at one of the cafes. (Photo courtesy of Brad Cavanaugh, Air One Inc.)

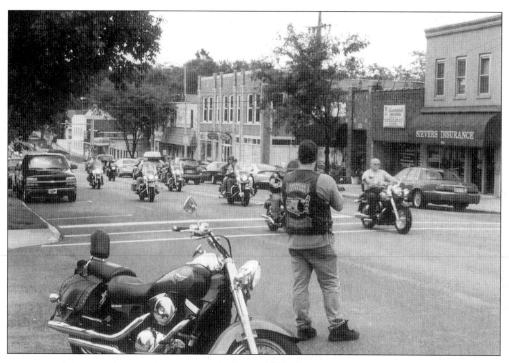

On August 31, 2002, Lincolnway was taken over by a Muscular Dystrophy Charity Ride. For nearly half an hour, (top) Lincolnway and all of its connecting streets were closed as hundreds of motorcycles drove through the city. From the corner of Greenwhich (bottom), the lines of motorcycles stretched as far as the eye could see. (Photo courtesy of Lanette Mullins.)

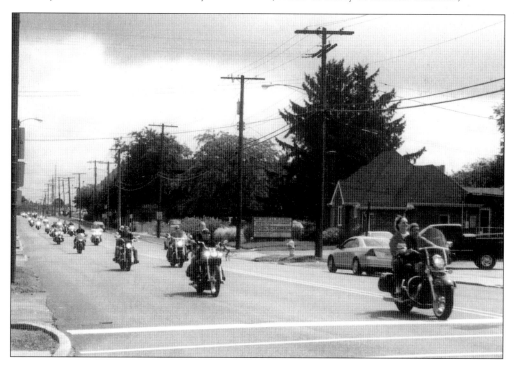

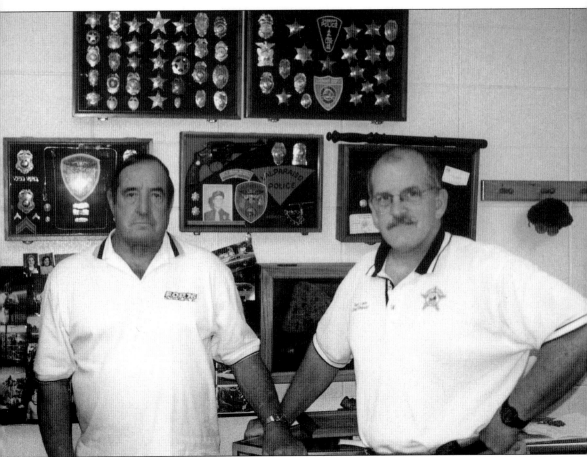

Chief Deputy David Lain, right, and Mr. Bill Black, right, are two important characters in the history of law enforcement in Valparaiso. Mr. Black is a retired city police officer. In the shadow box between the two men are Mr. Black's revolver and holster, patches from his uniform, his shields, his "come along," an early form of hand cuffs, and a photograph of Mr. Black when he was an active member of the police force. On the opposite wall in Lain's office is a case containing the rifle used by Sheriff Freeman Lane in 1938, along with a picture of the armored car used in the gunfight with the Easton Brothers. Both men are keeping a vital part of the city's history alive by passing on and documenting the stories of their lives and careers as well as their personal items and memorabilia so that another generation of Valparaiso residents can enjoy their past. (Photo courtesy of Lanette Mullins.)

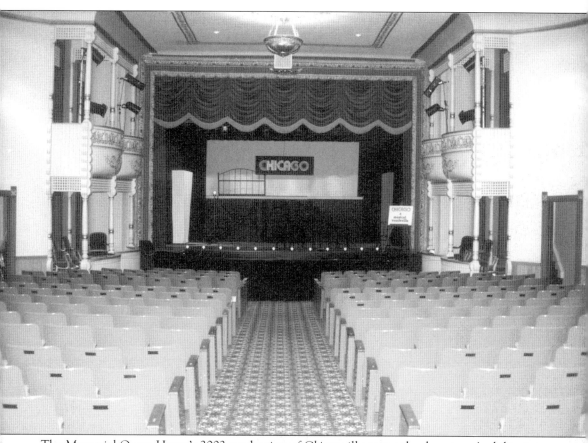

The Memorial Opera House's 2002 production of *Chicago* illustrates the downtown's ability to mix its history with a modern stage production. (Photo courtesy of Lanette Mullins.)

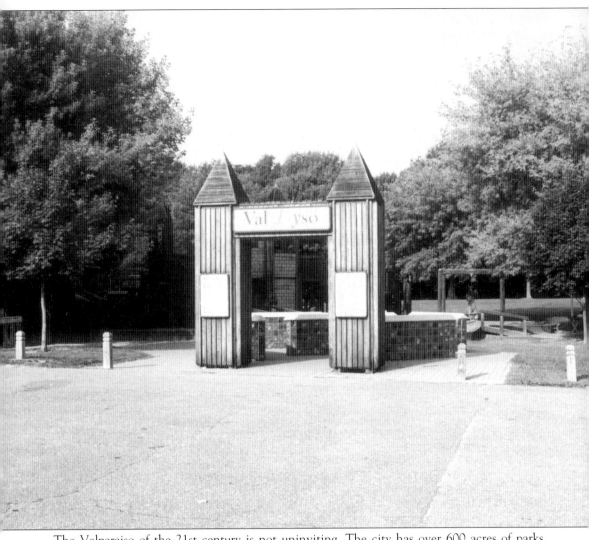

The Valparaiso of the 21st century is not uninviting. The city has over 600 acres of parks. Valpaplayso in Glenrose North Park, located on Glendale Boulevard, is in the middle of the northward expansion. (Photo courtesy of Lanette Mullins.)

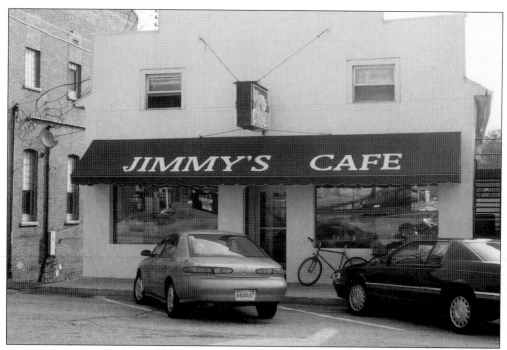

Jimmy's Cafe, located on Michigan Avenue, serves breakfast all day long. Even a modern city needs a hardy home-cooked meal. (Photo courtesy of Lanette Mullins.)

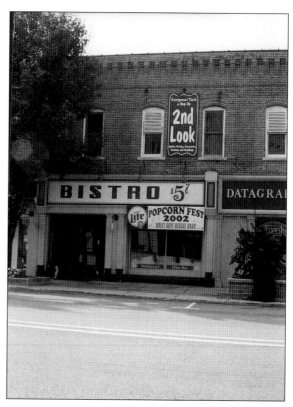

Bistro 1-5-7 opened in 2001 and offers fine dining. Though a new restaurant, it fits nicely into the downtown design scheme. (Photo courtesy of Lanette Mullins.)

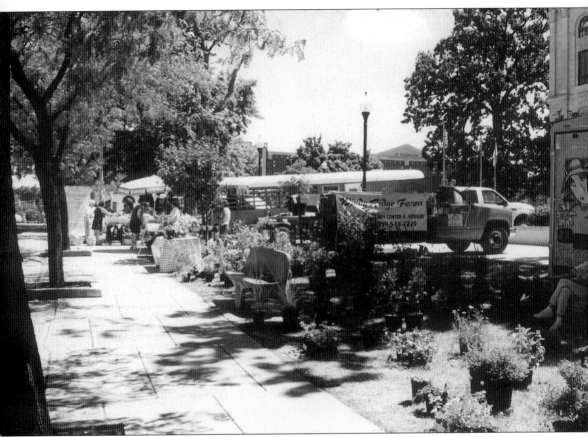

Farmers used to bring their produce to the city center to sell. Today we can go to the supermarket and get just about any kind of produce, any time of the year. This farmer's market, located on the courthouse square, is a reminder of times gone by. (Photo courtesy of Lanette Mullins.)

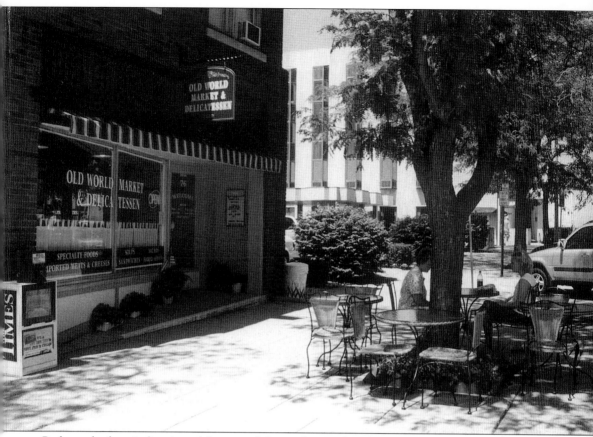

Perhaps the best indication of the mix of the modern is this photograph taken just outside the Old World Market Delicatessen. Patrons sit outside in the shade while the busy city moves on around them. (Photo courtesy of Lanette Mullins.)

BIBLIOGRAPHY

Albers, James W. *From Centennial to Golden Anniversary: The History of Valparaiso University from 1959–1975.* Indiana, Valparaiso University. 1976.

Baepler, Richard *Flame of Faith, Lamp of Learning, A History of Valparaiso University.* Missouri, Concordia Publishing House. 2001.

City of Valparaiso, Indiana. "History of Valparaiso." <http://www.ci.valparaiso.in.cityhistory/city_history.htm> 2002. (6 March 2002.)

Fewell, Gordon E. "The Four-State Pact Gets Its Man," *Official Detectives*, October 1938.

Neeley, George E. *Valparaiso: A Pictorial History.* Missouri, G. Bradley Publishing, Inc. 1989.

Porter County Sheriff's Department. "Jail Transition Team." <http://www.portercountysheriff.com/transition.htm

Sherman, Len *Popcorn King, How Orville Redenbacher and his Popcorn Charmed America.* Texas: The Summit Publishing Group. 1996.

University Relations. "Building Groundbreaking Set for April 27." (18 April 2002.) <http://www.valpo.edu/news/index/php?action=display&newsid=662>

Valparaiso University. "About Valpo. 24 October 2001." <http://www.valpo.edu/about_valpo/> (15 April 2002.)

Versau, Julia, et al. *Northwest Indiana. Oregionality: Sand, Steele & Soul.* Indiana: Northwest Indiana Newspapers. 2001.